IMAGES
of America

TRENTON

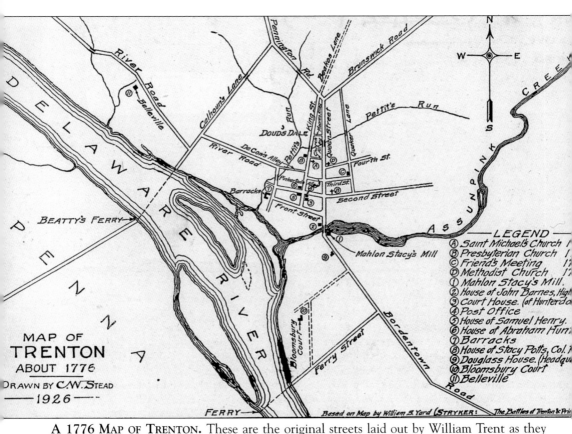

MAP OF
TRENTON
ABOUT 1776
DRAWN BY C.W. STEAD
1926

Based on Map by William S. Yard (STRYKER: The Battles of Trenton & Pri

A 1776 MAP OF TRENTON. These are the original streets laid out by William Trent as they appeared at the time of the Revolutionary War.

IMAGES
of America

TRENTON

Cathleen Crown and Carol Rogers

ARCADIA
PUBLISHING

Published by Arcadia Publishing
Charleston SC, Chicago IL, Portsmouth NH, San Francisco CA

Printed in the United States of America

Library of Congress Catalog Card Number: 2004116971

For all general information contact Arcadia Publishing at:
Telephone 843-853-2070
Fax 843-853-0044
E-mail sales@arcadiapublishing.com
For customer service and orders:
Toll-Free 1-888-313-2665

Visit us on the Internet at www.arcadiapublishing.com

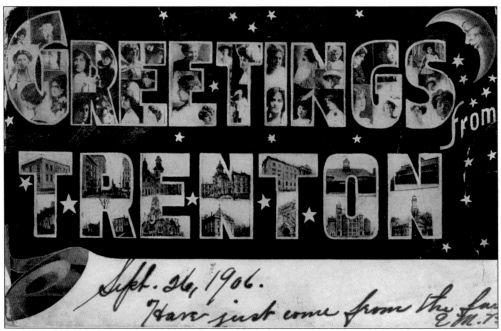

GREETINGS FROM TRENTON. Welcome! We hope you have a great time while you are here.

CONTENTS

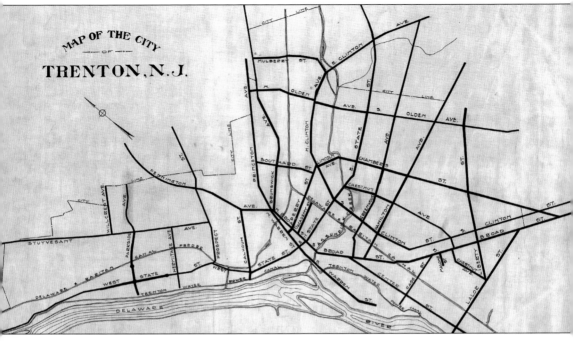

ACKNOWLEDGMENTS

Many people helped us create this book. We are indebted to all of them for their kindness. As is necessary with acknowledgments, we must limit the list. We offer apologies to anyone we neglect to name.

First, the staff of the Trenton Free Public Library: director Robert Coumbe and especially the Trentoniana Room's Wendy Nardi and Lynn Heil, whose exceptional knowledge of the Trentoniana Collection and unfailing guidance through our many long days of research were blessings. Next, Richard Patterson, director of the Old Barracks Museum; Judy Winkler of the Invention Factory Science Center; Brian Murphy of the Old Mill Hill Society; and Jeff McVey, for access to memorabilia and knowledge. All of these people graciously gave us access to and lent us photographs and postcards. The pages that follow are filled with pictures from their organizations' archives as well as their personal collections.

In addition, recognition is due to the great neighbors and homes that make up the Berkeley Square Historic District. As newcomers many years ago, we were taken in warmly and shown how to love Trenton.

Finally, to Sally Lane, director of the Trenton Convention and Visitors Bureau, who gave us the keys to her research files, photographs, and postcard collection. Without her encyclopedic knowledge of Trenton's history and people and her generous support, this work would not exist. Thank you.

A last acknowledgment to the readers of this book: obviously, there are things we missed; we hope that you will remind us of the many places, events, and peoples that are woven into the history and life of our city.

It is our joy to dedicate this work to our families: Ed Watkinson and Jim, Claire, and Evan Halliday; moreover, most especially to our parents, Mervyn and Joan Rogers and Ron and Eileen Crown.

INTRODUCTION

The story of Trenton begins in 1678, when some 20 Quakers left Yorkshire, England, to travel to America. The Quakers wintered in the fort at Burlington, New Jersey, and in the spring of 1679, set sail for the lands they had purchased at the head of the navigable waters of the De La Warr River. Approaching rocky outcrops in a sharp bend of the river, they stopped....

Led by Mahlon Stacy, they set to work building homes and clearing farmland. Three freshwater creeks surrounded them, providing fish in addition to drinkable water. Vast tracts of hardwood forests filled with game, wild fruits, and nuts provided them with shelter and food. They called their tiny settlement Ye Ffalles of Ye De La Warr. They shared this section of West Jersey with Lenni Lenape Indians, who had lived and farmed the area for many years. From the Lenapes they first learned of peaches, delicacies about which they wrote to their families in England.

Other settlers joined them and following Mahlon Stacy's death in 1714, Philadelphia merchant William Trent bought 1,600 acres from Stacy's son, Mahlon the younger. Trent began work on a manor house for himself, as well as the subdivision of his land. He laid out plans for a triangle-shaped village with King and Queen Streets, leading from the Delaware and meeting at the northern end of the village, the juncture of the Brunswick, Maidenhead, and Pennington Roads. Two other streets, Front and Second, intersected these, forming the base of the triangle. These streets exist today, though only Front Street retains its original name. Trent modestly called the newly divided village Trent's Town and went about selling the property, insisting that no one could build a business next to the same type of business he owned.

By the 1770s, the village known as Trenton had about 100 buildings, including an army barracks built during the French and Indian Wars. The Quaker, Episcopalian, Presbyterian, and Methodist congregations each owned land and a building for worship. Trenton was the crossing point for travel from Philadelphia to New York, with taverns, inns, and ferries to support riders on their journeys.

In December 1776, an event that is told to every American schoolchild occurred. Relying on the British to relax and enjoy the holy day, Gen. George Washington chose to attack Trenton on Christmas. Driving sleet and snow, as well as large chunks of ice on the river, delayed his planned attack until dawn of the following day. In just a few hours, the Americans captured more than 900 Hessian officers and soldiers; among the 150 dead was the commander Col. Johann Rall. No Americans lives were lost. By 11 a.m., it was all over. Exhausted, dressed in rags, ill from the cold and lack of decent food and sleep, the rebel forces had accomplished the impossible: an inconceivable and crippling blow to the world's greatest army.

Back in Pennsylvania on the next day and in danger of losing his army (enlistment agreements were up at the beginning of the new year), Washington gambled on reaching New Brunswick and gaining possession of British gold stored there. He returned to Trenton on January 2, 1777. At the same time, coming from Princeton were 10,000 British troops led by Gen. Charles Cornwallis. The two armies engaged; smaller in number, the Americans retreated over the Assunpink Creek Bridge and became trapped between the creek and the river, which was at their backs. From the higher side of the creek, they were able to fire downhill into the enemy's midst. Three times Cornwallis ordered his men to take the bridge, and three they failed. Later, soldiers wrote in their diaries that the creek ran red.

The British and the river were between the American army and freedom. Washington and his officers met at the home of QM Alexander Douglass. Trentonian Gen. Philemon Dickinson suggested that they depart town via the Sandtown Road. Doing so, they were in battle with British troops in Princeton before Cornwallis rose to face an empty field of battle. During the banquet following the surrender at Yorktown, seven years later, Cornwallis conceded that he lost the war when Washington gave him the slip in Trenton.

Time flew by, and Trenton thrived. In 1790, Trenton was chosen as New Jersey's capital city. For a few months in 1794, the town was the nation's capital; later, in the vote for a permanent seat of government, Trenton lost by one vote to a tract of Potomac swampland. However, this gave Trenton the distinction of being the only American town to have been the capital of all four forms of secular government: municipal, county, state, and country.

Through the 1800s, Trenton grew along with the Industrial Revolution. The ironworks of Peter Cooper and Abram Hewitt manufactured the first I beam, making the modern skyscraper possible. Cooper convinced his friend John A. Roebling, designer of the Brooklyn Bridge, to move his iron rope manufactory from Saxonburg, Pennsylvania, citing the abundant resources and transportation routes of Trenton. In the 1850s, English potters migrated to the town, enticed by natural deposits of clay. The rubber industry, too, found Trenton hospitable. Immigrants followed family and friends to Trenton's growing ethnic neighborhoods. As it entered the 1900s, Trenton was an industrial power on the Eastern Seaboard.

In 1929, Trenton celebrated the 250th anniversary of the Quakers settling at Ye Ffalles. Trentonians could boast that the city ranked first among the nation in pottery production; fourth in linoleum; sixth in rubber tires, wire and cable, and rubber products of all kinds; and seventh in iron and steel. Some 400 businesses provided jobs for 30,000. In Trenton banks were $100 million dollars—which quickly changed as soon as the Great Depression began.

After weathering the Depression, the city joined the nation in the war effort. Housewives went to work in the factories. Trenton supplied a constant stream of equipment, which helped win the European and Pacific conflicts.

During the postwar years, Trenton's resources were siphoned off into the suburbs. One by one, the factory owners—many of them born and bred here—sold their businesses to large conglomerates. Children grew up and moved away; their parents soon joined them. Trenton lost more residents as local industries began to shrink. The city's role as an industrial power ended by 1974, when the former Roebling plants stopped production.

In the 1990s, a turnaround began. By the midst of the city's 321st year (1999–2000), Trenton had a population of about 90,000 with businesses ranging from downtown shops to a variety of offices, restaurants, light industry, and government facilities. Today, the city has eight historic districts and more than 20 private and public-owned landmark buildings. Sports play a role here, with the completion in the past decade of both a baseball stadium and hockey/basketball arena for Trenton's minor league teams. In addition, the city attracts visitors to the Old Barracks, Trent House, City Museum, and State Museum. Mahlon Stacy and his compatriots would find the settlement they knew grown to a capital city of diverse cultures and neighborhoods well on the way to its 400th anniversary.

One

CONSTANTS

THE BEGINNING. The story of Trenton is recognizable in a few landmarks. Thirty-five years after the settlement of the Falls, William Trent built a summer home far away from the summer's heat, noise, and odors of Philadelphia, the largest city in the colonies. That structure symbolizes Trenton's beginnings. In the summer of 1999, Gov. Christine Todd Whitman unveiled a newly restored dome rising above the Capitol. That act could symbolize Trenton's ability to incorporate its past into its future.

Five houses survive from the 18th century and hundreds more from the 19th and early 20th centuries. The structures in this chapter, from manor house to churches to banks to memorials, are essential to Trenton's sense of self. As each one rose and survived the years that followed, it became one of Trenton landmarks. Bring a friend into town for an afternoon of sightseeing and a Trentonian will point out these sites.

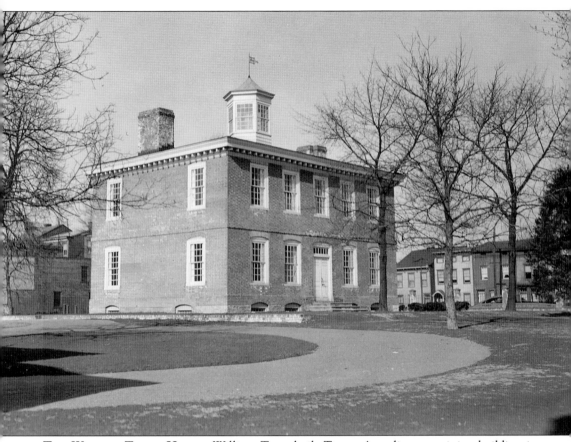

THE WILLIAM TRENT HOUSE. William Trent built Trenton's earliest remaining building in 1719. Born in Scotland, Trent made his way to Philadelphia, where he flourished as a city merchant, becoming a wealthy man. Like other well-to-do citizens, he chose to remove his family from the heat of the town to a summer residence where cooler, cleaner air prevailed. Although this may seem foolish to us since the cities are no more than 30 miles apart, Trent no doubt enjoyed the exchange of a noisy, odorous city, lacking in indoor plumbing, air-conditioning, and sewage systems, for the quiet life on his 800 acres upriver at Ye Ffalles. During the Revolutionary War, the house belonged to Dr. William Bryant, who treated soldiers from both armies. As one version of an old story goes, it was Bryant who had heard from a feverish patriot that the British were about to attack Trenton. Bryant sent this news to Col. Johann Rall, who carelessly placed the unread message in his pocket. Later, when the nation's capital was in New York, John and Esther Cox owned the property. First Lady Martha Washington was then a frequent visitor to the house, no doubt relaxing while making the five-day trip from Mount Vernon to New York.

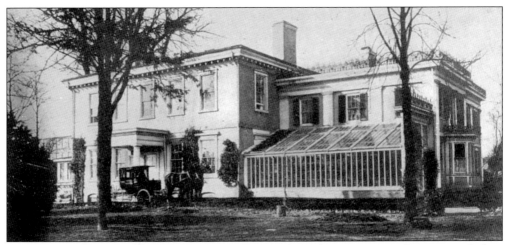

THE TRENT HOUSE BEFORE RESTORATION. Passing through a succession of owners, including mayors and governors, the property eventually came into the hands of Edward H. Stokes. Commemorating the 250th anniversary of the settling of Trenton, Stokes's son Edward A. Stokes announced that he would give the house and property on which it stood to the City of Trenton. In a dignified ceremony on October 30, 1929, he handed over the deed, stating that the size of the property could not be decreased and the house was to be restored to its 1719 appearance, that the city could use it only for a public library, historical museum, or art gallery, and that if these and other stipulations could not be met at any time, the house would revert to the Stokes family.

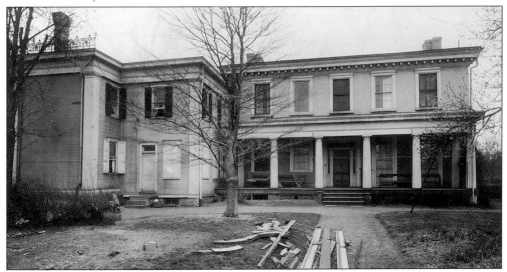

THE TRENT HOUSE DURING RESTORATION. Originally intended as a branch of the Trenton Free Public Library, the project floundered when neither the library nor the city had the funds for restoration work. When the Civil Works Act of 1933 was announced, historical restoration was among the intended projects for the unemployed to take up. The library quickly submitted the Trent House project and, being accepted, work began in January 1934. Work included the removal of the 1850s wooden addition, as well as the Victorian improvements that adorned the interior. On October 14, 1936, William Ely, state administrator of the Works Progress Administration, handed the house key over to John J. Cleary, chairman of the Library committee in charge of restoration.

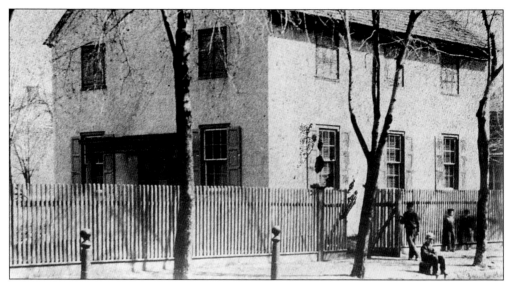

THE QUAKER MEETINGHOUSE. This meetinghouse is at the corner of North Montgomery and Hanover Streets. The Quakers who settled Ye Ffalles of Ye De La Warr soon outgrew the ability to meet weekly in each other's homes. Built in 1739, this modest building was the first house of worship in Trent's Town. In December 1776, the meetinghouse was taken over by British Dragoons, who used it as a sleeping and training place. It is said that marks in the floor and stairs were a result of the dragoons' sword practice and faded from view in the first decades of the 1900s.

THE QUAKER MEETINGHOUSE, WITH ITS 1873 ADDITION. This picture shows the 1873 addition erected on the North Montgomery side of the building. To the left of the building, a small cemetery holds the remains of George Clymer, a signer of both the Declaration of Independence and the U.S. Constitution. Also interred here are Revolutionary War hero Gen. Philemon Dickinson and Dr. Thomas Cadwalader, the founder of Trenton and New Jersey's first library. It is believed that Mahlon Stacy, leader of the 1679 settlement of Ye Ffalles, is buried in a small Quaker cemetery located within today's Riverview Cemetery.

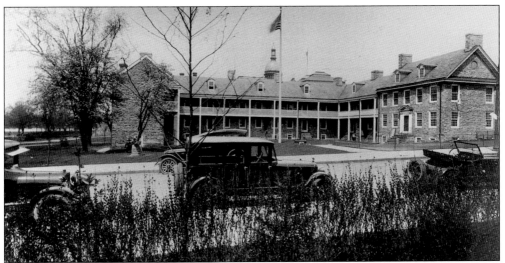

THE OLD BARRACKS. Built in 1758 to house British soldiers during the French and Indian Wars, this is the last of a number of barracks built up and down the Eastern Seaboard for the same purpose. In December 1776, the barracks housed the families of Hessian soldiers. Imagine their surprise on December 26, when they awoke to the roar of cannon fire coming from the orchard behind them.

THE DOUGLASS HOUSE, 1766–1874. One of Trenton's oldest structures, the Douglass House (c. 1766) has had four locations over the past 200 years. Originally owned by Alexander Douglass, a quartermaster with the American army, the house became a landmark for its association with the Revolutionary War. During the battle of January 2, 1777, Gen. George Washington made this modest four-room house his headquarters. From here, he planned and directed his troops' evacuation of Trenton by night in order to escape certain defeat the following day. On January 3, Britain's Gen. Charles Cornwallis was stunned to discover that the site of the battle had moved to his rear in Princeton. In a one-two-three punch through Trenton and Princeton, Washington had turned the tide of the Revolution.

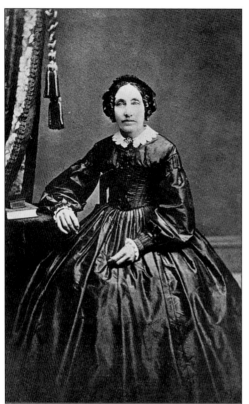

ANN DOUGLASS (1803–1893). Ann Douglass, great-niece of Alexander Douglass, was the last of the Douglass family. In the early 1850s, she sold the house to the Lutheran Church, which used it as a rectory until moving to newer facilities. She left a relic of the Battle of Trenton, a Hessian's sword, to a friend of the family who had admired it as a child. At age 21, she had been a part of the welcoming celebrations for the Marquis de Lafayette. It was in a Trenton tavern that Lafayette took his last leave of the U.S. Congress, following a triumphant 1824 tour of the country.

THE DOUGLASS HOUSE, CENTER STREET, 1875–1924. After the Lutherans had outgrown their church, they expanded the building on the site occupied by the Douglass House. They sold the Douglass House, which was then moved by its new owner to 478 Centre Street. Later occupied by tenants, the house fell into disrepair.

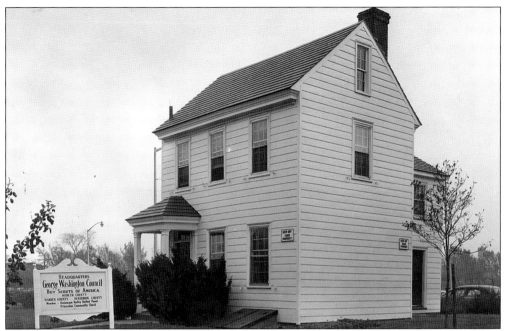

THE DOUGLASS HOUSE, STACY PARK, 1925–1976. Gen. Wilbur Sadler, who managed the development of Stacy Park, effected the third move in recognition of the historic significance of the Douglass House. While here, the house served the Boy Scouts of America's George Washington Council.

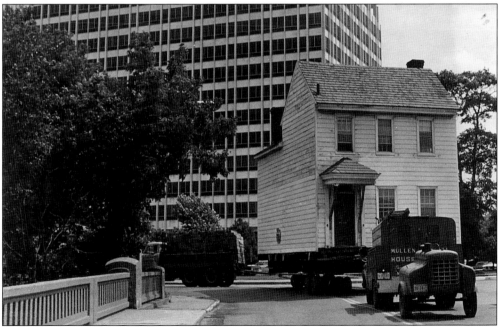

THE DOUGLASS HOUSE EN ROUTE TO ITS CURRENT LOCATION. In preparation for America's bicentennial celebration, the Douglass House traveled from Stacy Park to the newly created Mill Hill Park in 1972. The city of Trenton maintains the building, which now serves as a two-room museum celebrating the First and Second Battles of Trenton.

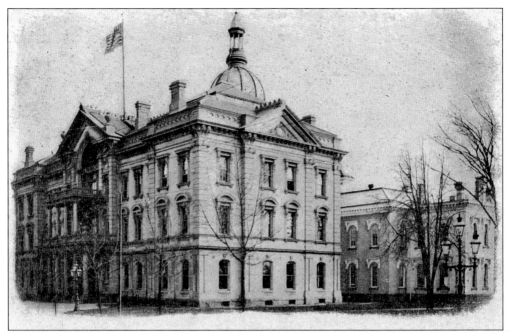

THE CAPITOL BUILDING. This delicately lined postcard belies the sheer majesty of the N.J. Statehouse. A continuum of construction, the statehouse, added to since its original 1792 structure, is shown here in 1903.

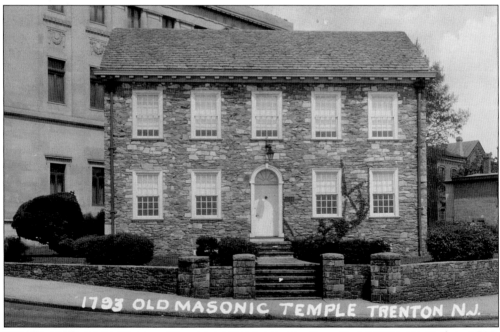

THE FIRST MASONIC TEMPLE, CORNER OF BARRACK AND LAFAYETTE STREETS. Built in 1793, this fieldstone building housed the first group of Masons in Trenton, Lodge 5. Trentonian Daniel Coxe received a charter from the British Free and Accepted Masons to bring the secret society to America. Lodge 1 is in Boston. Trenton's first Masonic Temple is still owned by the Masons and currently houses the Trenton Convention and Visitors Bureau.

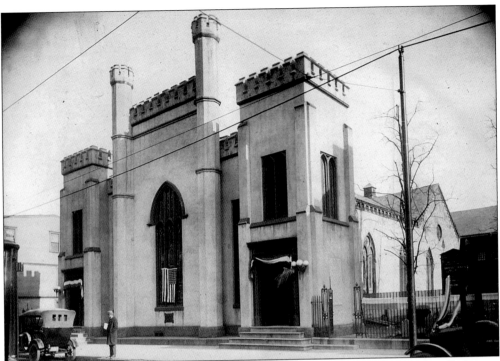

ST. MICHAEL'S EPISCOPAL CHURCH. Trenton's first Church of England was originally known as the English Church. Buried in the graveyard alongside this building are David Brearley, who was a signer of the U.S. Constitution and the first chief justice of the State of New Jersey, and Josephanna Bonaparte, the 4-year-old daughter of Joseph Bonaparte and niece of Napoleon.

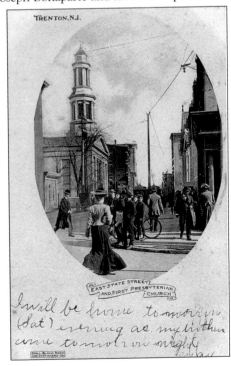

THE FIRST PRESBYTERIAN CHURCH. The First Presbyterian Church has served the people of Trenton since 1726. Buried here are some of the earliest Trentonians, Col. Johann Rall and the 150-or-so Hessians who died at the First Battle of Trenton, and the first army chaplain to die in the service of America. This postcard is undated.

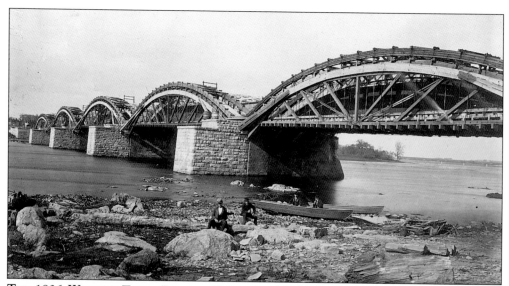

THE 1806 WOODEN TRUSS BRIDGE. This is the first bridge in America built specifically to accommodate interstate commerce. The toll for crossing from New Jersey to Pennsylvania depended on the method of transportation. With four horses and a carriage, it was 75¢; with four horses and a stage wagon, 62¢; with two horses and a carriage or wagon, 37¢; by foot, 3¢; for each sheep or pig, 1¢. Opening this bridge dealt a heavy blow to Trenton's ferry operators. The bridge was abandoned in December 1875, having been replaced by a more modern bridge that incorporated trains, horse-drawn vehicles, and pedestrian traffic. A few feet south of the site of this bridge, the "Trenton Makes the World Takes" Bridge was erected in 1928 for vehicular and foot traffic. A separate bridge conveys rail traffic; two other bridges, the Calhoun Street and Route 1 bridges, also carry vehicles between New Jersey and Pennsylvania.

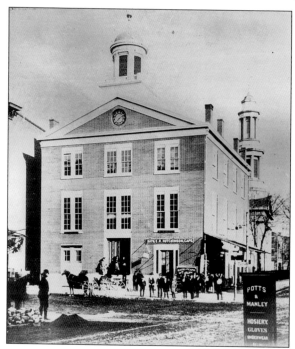

THE OLD CITY HALL. The first city hall opened in 1837 at the corner of State and Broad Streets, just a step away from the First Presbyterian Church. Three stories tall, the building accommodated city officials and departments, as well as first-floor shops and a second-floor auditorium.

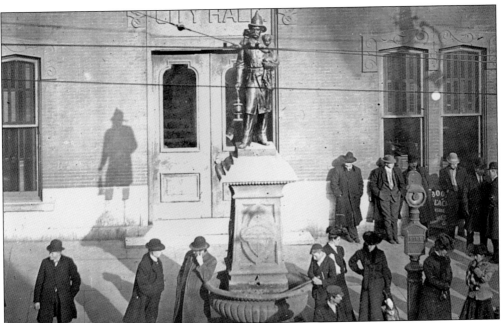

THE FIREMAN STATUE AT OLD CITY HALL. This statue has been a city treasure for as long as can be remembered. Judging from the picture, perhaps it has been longer. The statue now stands in front of city hall and was scheduled to be moved to the newly expanded Trenton Fire Company Headquarters on Perry Street.

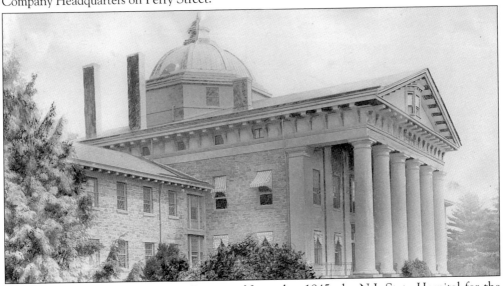

THE TRENTON STATE HOSPITAL. Begun in November 1845, the N.J. State Hospital for the Insane received its first patients in May 1848. More than a century and a half later, Trenton Psychiatric Hospital continues its rehabilitative efforts on the original site. Dorothea Dix, a pioneer advocate for the mentally ill, selected the site and played a prominent role throughout the hospital's early years. After much traveling to promote the rights of these troubled individuals, Dix chose to return to this lovely campus to live out the rest of her days. This 1889 photograph shows the small dome of the administration building. Destroyed in a fire, the central portion of the building was rebuilt in the architectural style of its time.

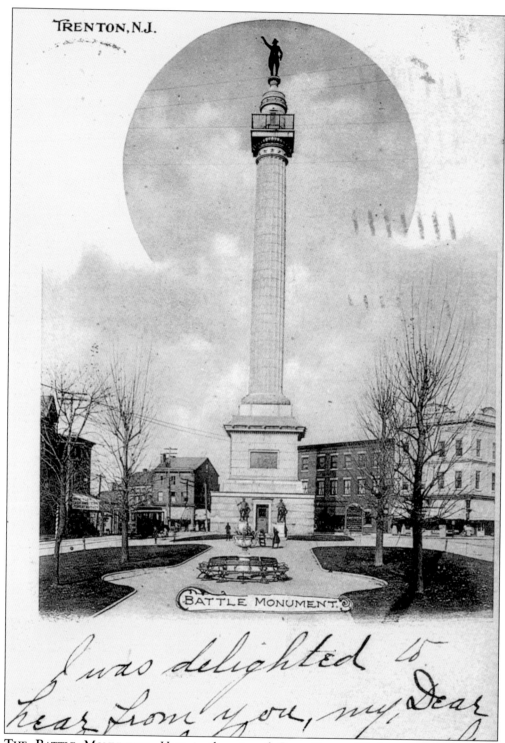

TRENTON, N.J.

BATTLE MONUMENT.

I was delighted to hear from you, my Dear

THE BATTLE MONUMENT. Here is the site of Gen. George Washington's artillery on December 26, 1776. From this vantage point, gunmen led by Capt. Alexander Hamilton fired directly down King and Queen Streets.

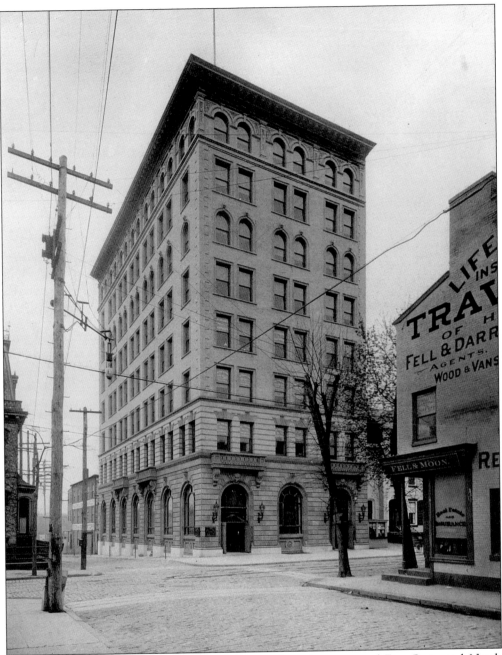

THE BROAD STREET BANK. This bank is located at the corner of East State and North Montgomery Streets. Organized in 1887 at 188 South Broad Street, the bank quickly outgrew its accommodations and moved to this location in 1900. Towering over the street, the nine-story building was Trenton and Mercer County's first skyscraper. In 1912, the bank expanded with a 12-story addition to its right.

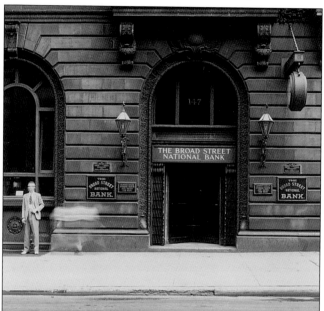

THE MAIN ENTRANCE TO THE BROAD STREET BANK. Behind this door stood Trenton's first revolving door. Beyond that was a new method of climbing floors: Trenton's first elevator. Perhaps the gentleman on the left has just experienced these technological wonders.

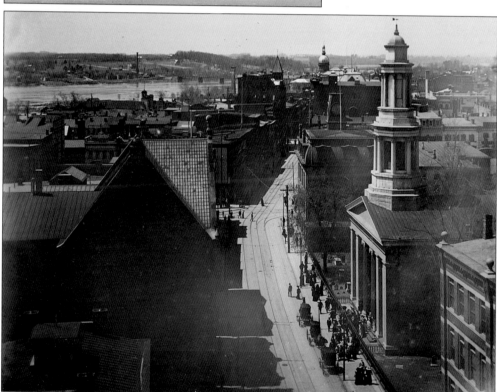

STATE STREET, LOOKING WEST FROM THE ROOF OF THE BROAD STREET BANK. Sophisticated city dwellers and rural farmers alike marveled at the view from the roof of the Broad Street Bank. After admiring the revolving door and being petrified by the sensation of moving upward in the elevator, women were known to have fainted upon first seeing this view. On the right is the First Presbyterian Church, and in the middle distance is the statehouse.

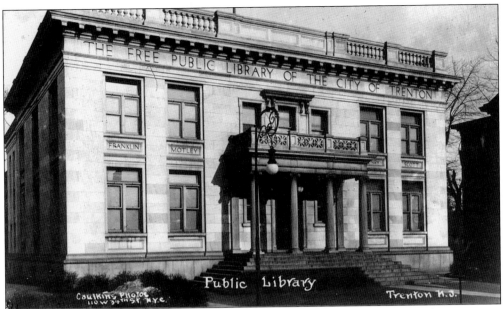

THE TRENTON FREE PUBLIC LIBRARY. Erected in 1900 and formed in 1750 with a monetary gift from Dr. Thomas Cadwalader, the Trenton Public Library was the first library in New Jersey. Cadwalader asked his associate Benjamin Franklin to purchase a first-class collection for the village of Trent's Town. Through the years, Franklin's purchase of 50 books (of which 14 remain) has evolved into today's modern library.

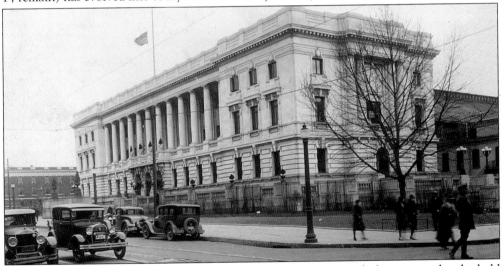

CITY HALL. The decision to move away from the city's downtown hub was considered a bold proposal in 1908. The Trenton Common Council named Ferdinand Roebling, Gen. C. Edward Murphy, and Jonathan Blackwell as the City Hall Commission, with responsibility for the entire project. Ground was broken in November 1908, and the white-marble-clad building opened in November 1910 at a cost of $850,000. A large mural in the council chambers depicts Trentonians at work in the iron and steel mills and in the potteries. Roebling, Murphy, and Blackwell commissioned Everett Shinn, a painter known for his gritty depiction of lower-class urban workers, to complete a mural for the building. With the addition of the mural in 1911, the commission had created a home of government worthy of its citizens.

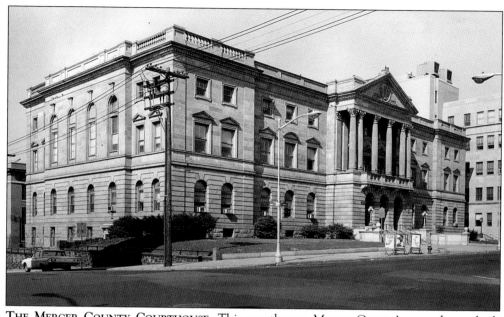

THE MERCER COUNTY COURTHOUSE. This courthouse, Mercer County's second, was built in 1901.

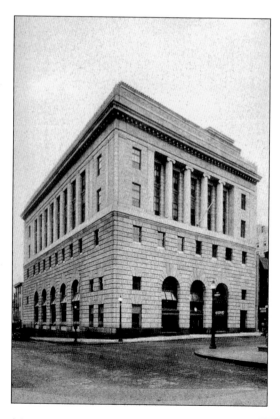

THE CORNER HISTORIC. A building has stood at this site since before the Revolution. Once the private home of Samuel Henry, it gave way to the Blazing Star, subsequently the Thirteen Stars Tavern, the French and Indian Arms, and the City Tavern. The lower floor contained the barroom. Legend has it that on July 4, 1780, several townsmen drank 13 toasts to the new republic. This feat was repeated when Trenton received news of Gen. Charles Cornwallis's surrender at Yorktown. Two rooms on the main floor were combined to make one long room, and it was in that room that the new U.S. government met in 1794. In 1836, the First Mechanics and Manufacturers Bank bought the old tavern and replaced it with a new two-story brick structure. Over the years, the building was razed and replaced and has been in its present form since 1914.

THE BRONZE DOORS AT THE CORNER HISTORIC. Massive doors provide entrance to the banking floor. The panels on the door feature engravings of George Washington, Benjamin Franklin, the Marquis de Lafayette, and Alexander Hamilton. The first and last mentioned were present at the first Battle of Trenton, and the middle two were frequent Trenton visitors.

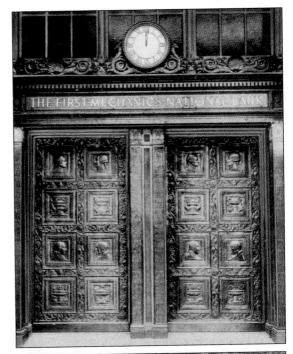

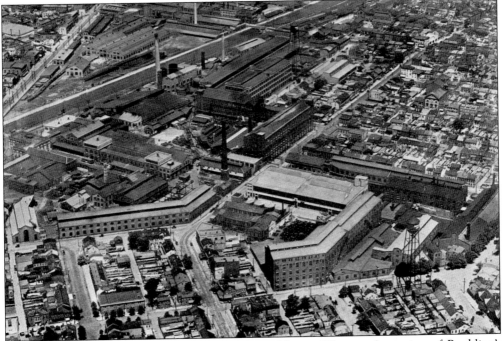

AN AERIAL VIEW, JOHN A. ROEBLING'S SONS UPPER WORKS. A portion of Roebling's Trenton plant appeared as the cover of the July 1926 *Trenton* magazine. Inside, a brief article notes the passing of Washington A. Roebling, president of John A. Roebling's Sons Company, in his 89th year. Buildings in the photograph have been converted into shops, a museum, a senior citizen home, and office space. In 1926, *Trenton* sold for 10¢ at newsstands and for 2¢ by subscription.

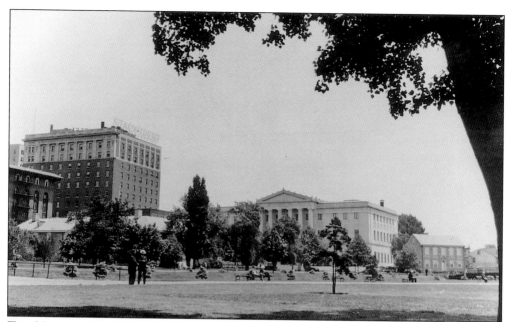

THE MASONIC TEMPLE. The Masonic Temple is located at the corner of Barrack and Front Streets. Built in the 1930s, this example of the beaux art-style of architecture brought five lodges together under one roof.

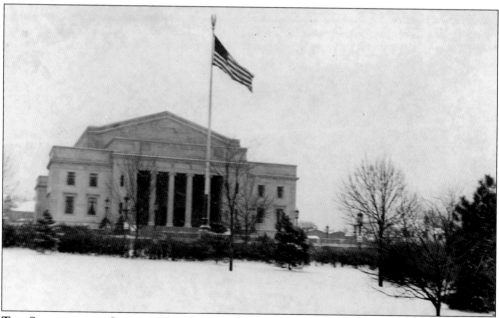

THE SOLDIERS AND SAILORS WAR MEMORIAL. The State's tribute to N.J. men and boys who served in World War I was built in the early 1930s with donations from public and private sources. The Court of Honor at the front of the building was paid for in pennies by the schoolchildren of New Jersey. Rather than a monument to glorify war, the memorial glorifies peace: the memorial committee chose to build a theater that celebrates life in a building that bespeaks public pride. The State of New Jersey recently completed a thorough restoration of the War Memorial.

Two

INDUSTRIAL YEARS

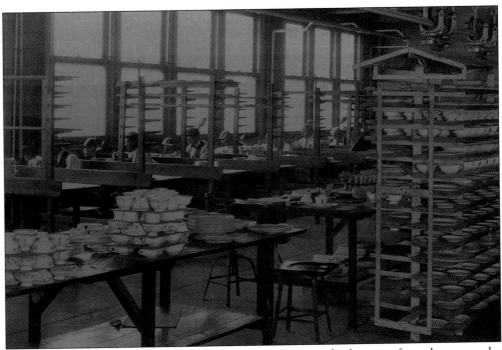

BUSINESS IN TRENTON. One of Trenton's first businesses was the ferrying of travelers across the Delaware River from New York to Philadelphia. Long before Robert Fulton was demonstrating his steamboat on the Hudson, Trenton's John Fitch was operating a daily steamboat service to Philadelphia. From the steamboat to the Spirit of St. Louis and from the White House to the highest points of the Golden Gate Bridge, Trenton's industries led the parade down the road of progress.

These were busy years for Trenton and its citizens. In addition to the increased population, the influx of industry, and the expansion of shops, there were social events and far-reaching wars, politics, and everyday life. Propelled by industry, Trenton moved rapidly from the Civil War to World War II.

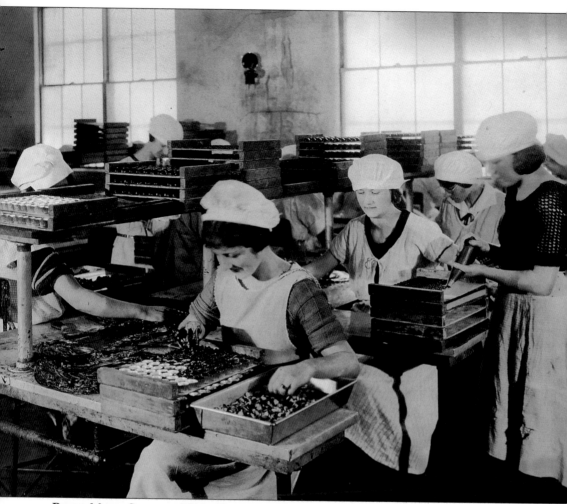

Belle Mead Sweets, 1918. *Trenton* magazine of November 1925 tempts its readers with an article touting the benefits of "pure" candy. It states that modern chemists claim pure candy is extremely nutritious, possessing carbohydrates, the heat-and-energy producing elements. Only the finest ingredients were used at Belle Mead: figs, dates, pistachios, pure cakes of maple syrup, plump oranges, cherries untainted with coal tar dyes, fresh 22% cream, and molasses from Barbados (because American molasses contained sulphur dioxide). Anything else was unnatural.

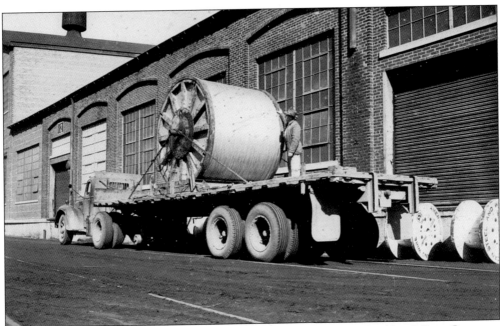

A Spool of Wire Rope, Roebling Yard. The impact of John A. Roebling's Sons Company on the city of Trenton was enormous. From the earlier 1850s until the 1970s, this wire rope company employed thousands of Trentonians and shipped wire around the world. Roebling wire was used in the Roebling-designed Brooklyn Bridge, on San Francisco's Golden Gate Bridge, and on many other spans. The Roeblings invested in a new gadget called the telephone; Alexander Graham Bell used their wires for his invention. The Otis elevator relied on Trenton-made rope for the Empire State Building and the Washington Monument. Even the *Spirit of St. Louis* could not have reached Paris without Roebling wire.

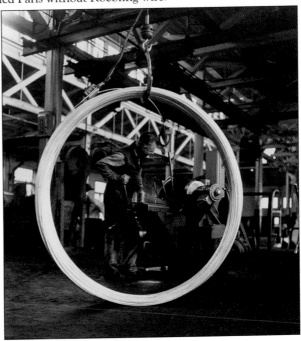

A Coil of Wire Rope, Roebling Factory. At times, the factory operated around the clock, especially during the years of WWII. Output of wire rope is unfathomable, with many contracts requiring thousands of miles of cable. Older Trenton natives like Nan C. Hunt, who grew up in the shadow of the bustling plant, were struck by the eerie silence that hung over the surrounding neighborhoods after the factory doors closed for the last time.

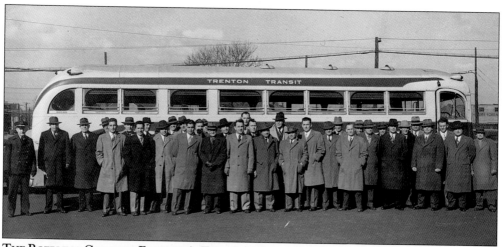

THE ROEBLING COMPANY FOREMEN'S TRIP. Seen boarding a Trenton Transit bus, the Roebling's factory foremen are off to New York City to view a Safety Exhibition in March 1947.

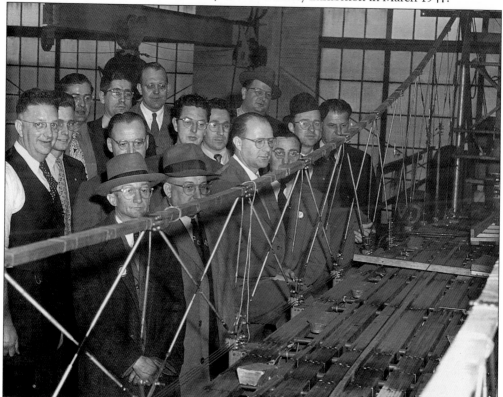

A MODEL SUSPENSION BRIDGE, ROEBLING FACTORY. Tours of the busy industrial plant were arranged for employees' families. Shown here are members of United Steel Workers Local 2110 and 2111 previewing the center of an event in April 1947. This model suspension bridge was in the physical-testing laboratory. Shown are, from left to right, as follows: (front row) Charles Baum, Charles Nemeth, Michael Baretta, Miles Cannon, and Andrew Tackas; (middle row) Peter Butchon, William Orkfitz, Peter Rossi, and George Blaskovitz; (back row) G. Jaggers, ? Boyle, Charles Egeli, Julius Papp, and John Cyenes.

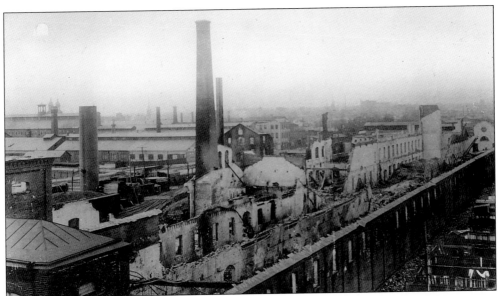

ROEBLING, AFTER THE FEBRUARY 2, 1908 FIRE. The loss of buildings to fire was a constant thorn in Charles Roebling's side. People rumored of employees with possible reasons for starting a fire—some who were upset over low wages without negotiation and later, others who were union members unhappy with management. Most likely, the cause was not as interesting, for the company dealt with hazardous materials every day. It is easy to guess that it was either a smoldering cigarette or a small waste can fire that led to the devastation. This 1908 event sent Roebling back to the drawing board to rebuild.

MARKET STREET, LOOKING WEST TO SOUTH BROAD. Market Street takes its name from the old city markets that used to stand in the middle of both Market and Broad Streets. Regional farmers brought their produce into the city, sold their chickens, vegetables, and fruits, and then circulated through town—getting a haircut or buying new shoes, clothes, seeds, household goods, and so on. In the market their stalls stood alongside the smaller shops of Trenton, which moved on to storefronts when they had the capital. This stretch of Market Street cleaves the Mill Hill Historic District.

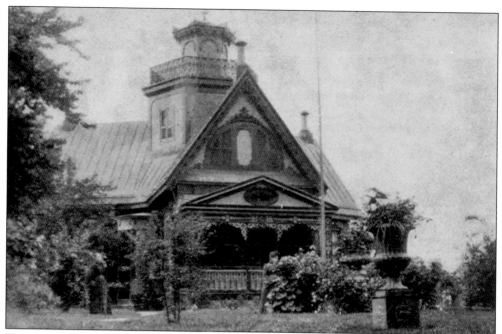

THE JOHN THROPP HOUSE, LEWIS STREET. Located in what is now the Mill Hill Historic District, the Iron House was indeed constructed entirely of iron. One can imagine what a curiosity it must have been. The Thropps razed it for expansion of the company plant, located next door.

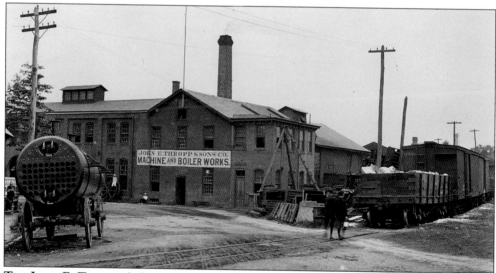

THE JOHN E. THROPP & SONS COMPANY. Trenton had two Thropp families conducting three businesses. John E. Thropp and his family were iron founders and machinists in the Mill Hill section of town. William R. Thropp & Sons Company, operating out of 968 East State Street were also machinists. Beginning in 1895, the John E. Thropps operated Eureka Flint and Spar at the corner of Greenwood and Lewis Streets. Eureka mined, imported, and pulverized supplies for the pottery, porcelain, tiles, glass, and paint industries. These industries turned to Trenton for materials. Eureka and Golding & Company, another Trenton company, were the top-rated producers of these supplies in the United States.

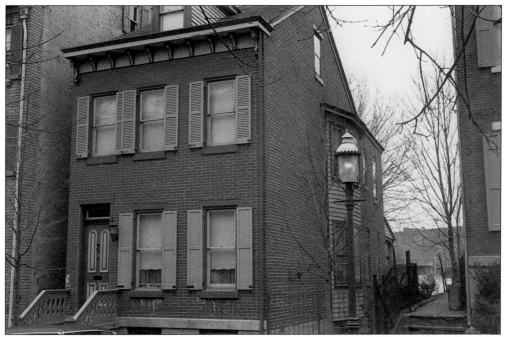

NO. 146 MERCER STREET. Mill Hill is the first landmark historic district in Trenton. Private residences line Mercer and Jackson Streets, while Market Street and South Broad Street are mostly commercial. The majority of the properties were constructed from 1840 to 1880. The district contains a handful of stand-alone houses.

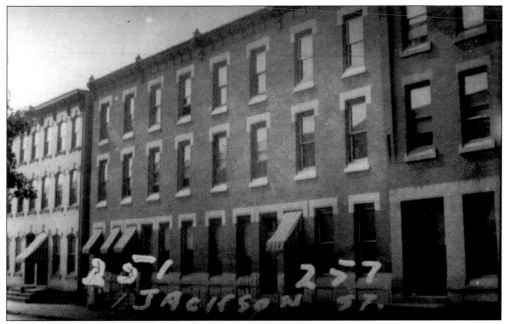

ROW HOUSES ON JACKSON STREET. Row houses of various sizes dominate the district. Part of the significance of Mill Hill was that plant owners then lived side by side with their employees —there was no distinction in lifestyles. In the 1880s, the wealthy residents began moving toward more elite houses and properties to differentiate themselves from their employees.

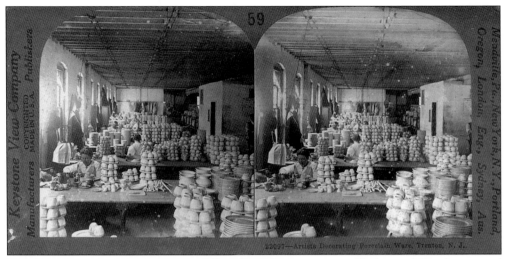

59

23097—Artists Decorating Porcelain Ware, Trenton, N. J.

THE STAFFORDSHIRE OF AMERICA. When English pottery men Taylor and Speeler opened their business in Trenton, they began an industry that would gain Trenton the nickname the Staffordshire of America. While potters had been a part of Trenton's history since her earliest days, it was not until Taylor and Speeler that a giant industry was spawned. Fellow potters soon followed and as one potter outgrew his space, he would sell to a smaller operator looking to expand. Potteries came and went, some operating for one or two years, some lasting for generations.

LENOX INCORPORATED. Walter Scott Lenox (1859–1920) lived all of his life in Trenton and began his career in pottery and porcelain as an apprentice for the Ott & Brewer Company. He apprenticed for Isaac Broome, who is recognized, along with his disciple, as one of the greatest pottery men of the pottery boom days of the late 1800s. Soon after achieving success in his own right, Lenox became blind and lost the use of his legs. This did not deter him from his art, and he continued as head of the company until his death. The firm's headquarters are now found in neighboring Lawrenceville.

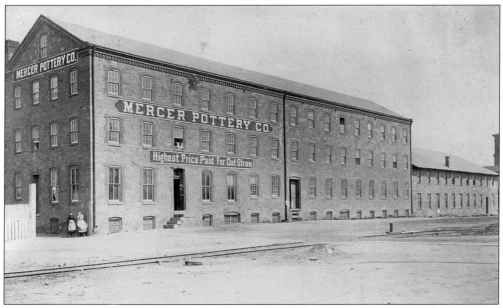

MERCER POTTERY. In the dizzying spin of pottery owners and buildings, the Mercer Pottery Company operated for several years under the guidance of James Moses.

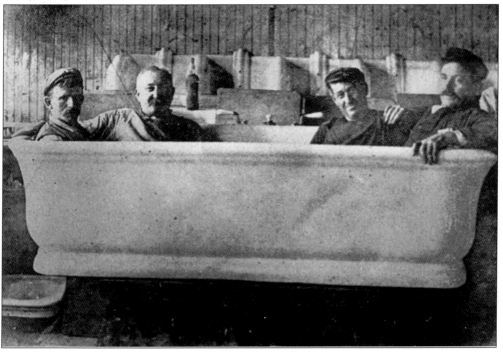

PRES. WILLIAM TAFT'S BATHTUB. The J.L. Mott Company, manufacturers of enameled cast-iron tubs, began operations in Trenton in 1902. In 1909, the factory was commissioned to produce a bathtub that could accommodate the newly elected and rather portly Pres. William H. Taft. The tub weighed 600 pounds and held 50 gallons of water. According to White House records, Pres. Woodrow Wilson, following his inauguration, sold the tub to William Randolph Hearst. The tub was shipped to Hearst's New York City address and then disappeared.

Photographed by J. Good, Trenton, N. J.

SOLDIERS' REST. Thought to be the oldest photograph of Trenton, this fading picture shows a welcoming committee for returning Civil War soldiers. A young Edmund C. Hill, who brought about the creation of Cadwalader Park, is thought to be the boy to the left of center.

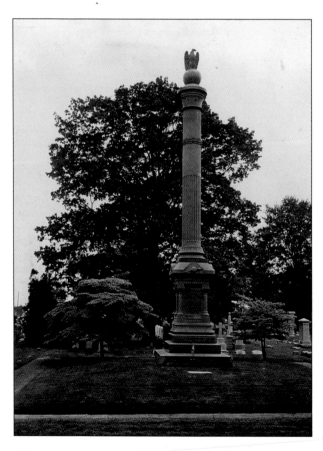

THE GEN. GEORGE MCCLELLAN MONUMENT, RIVERVIEW CEMETERY. "Little Mac" is greatly admired for his role as commander of the army of the Potomac during the first two years of the Civil War. Criticized, however, for not pushing his advantages, he was relieved of duty by Pres. Abraham Lincoln in November 1862. Reassigned to Trenton, he ran for president against Lincoln in 1864, carrying only three states. He continued as a popular New Jersey politician and was elected governor in 1873, serving until 1881. He retired to his home in Orange and died in 1895. His body was brought to Trenton for burial, and the monument was erected later. Also buried here are Gen. Gershon Mott and other members of the Grand Army of the Republic. This small cemetery-within-a- cemetery is unusual in that black servicemen and white servicemen are buried side by side.

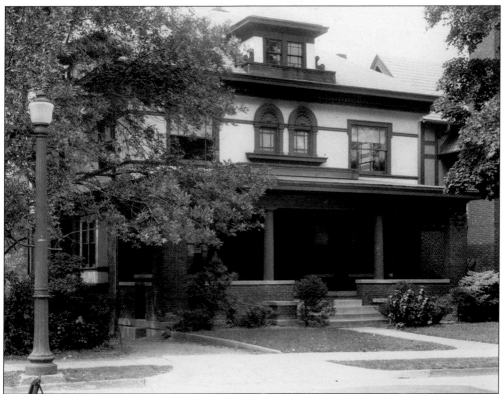

No. 415 Greenwood Avenue, Greenwood-Hamilton Historic District. The Greenwood-Hamilton District features two broad parallel avenues with large, spacious properties and homes. Between the two lie more narrow streets that are filled with side-by-side row homes. Pottery owners and other well-to-do businessmen populated the outer avenues, while their employees occupied the smaller residences. Recent owners have skillfully restored many of the homes in Greenwood-Hamilton.

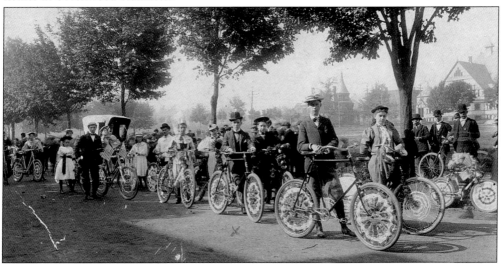

A Bicycle Parade, Greenwood Avenue. What fun this parade must have been, and what a perfect location. You can feel the spaciousness of the avenue and the size of its dwellings.

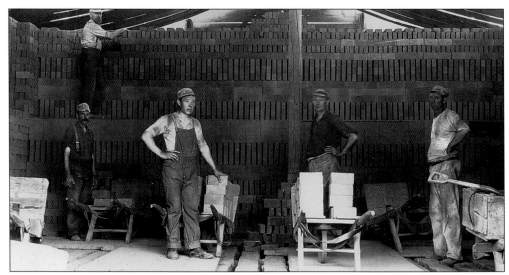

DONOHUE & NOLAN, BRICK MANUFACTURERS. Brick building was an established industry in Trenton when the 1881 City Directory listed John Donohue, brick maker, boarding at 135 Pennington Avenue. By 1885, Donohue co-owned Donohue & Nolan at Calhoun and Kirkbride Avenues. The 1920 City Directory listed John Donohue as living at 136 Brunswick Avenue and Thomas F. Nolan as living at 228 North Warren Street.

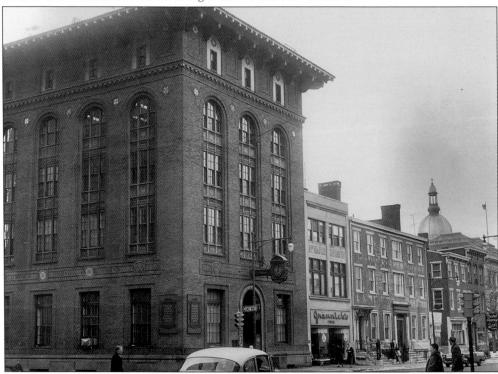

THE KELSEY BUILDING. Funded by former N.J. Secretary of State Henry Kelsey, this 1911 structure was designed by noted architect Cass Gilbert. Delicate tiling by Herman Mueller's Trenton firm graces either side of the entrance. The building now houses the Thomas Edison State College. Kelsey donated the building to the School of Industrial Arts.

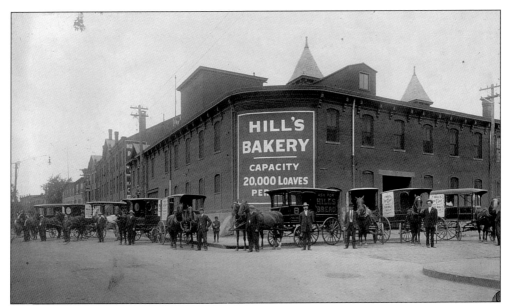

HILL'S BAKERY. Hill's capacity could certainly meet Trenton's demands—so much so, in fact, that the company made deliveries twice a day to 600 stores. Hill's fleet of 12 auto wagons and 10 carriages was a familiar sight throughout town.

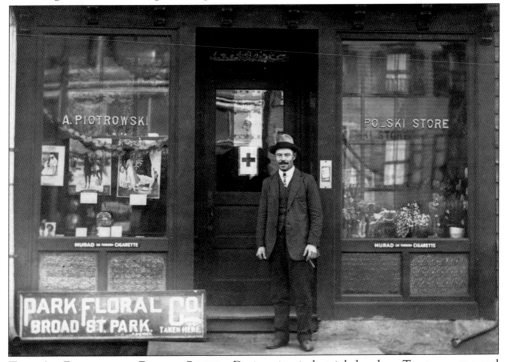

THE A. PIOTROWSKI POLSKI STORE. During its industrial heyday, Trenton attracted foreign-born people who were hoping to realize the American dream. They gravitated toward their fellow nationalists, many of whom were employed in Trenton's major industries. These groups created pockets of ethnic neighborhoods, which survive today. Piotrowski and other Eastern Europeans settled in the northern part of town.

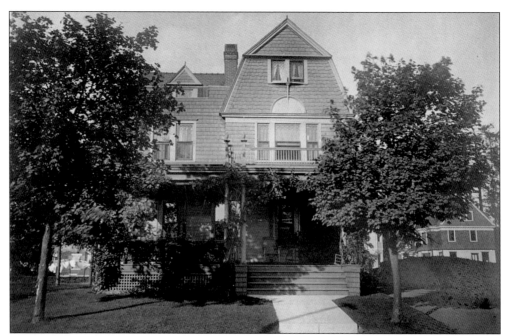

THE BERKELEY SQUARE HISTORIC DISTRICT. Created by local real estate agent Edward C. Hill and planned by the firm of Frederick Law Olmsted, Berkeley Square appears on the National Register of Historic Places as one of the earliest examples of a planned suburban community. The *c.* 1893 Queen Anne-style residence pictured here is home to one of the authors of this book.

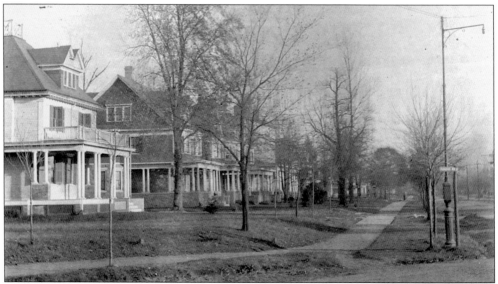

WEST STATE STREET LOOKING EAST FROM PARKSIDE AVENUE. Each house in the community originally known as Cadwalader Place (later divided into Berkeley Square and Cadwalader Heights and Place) had to be different from its neighbors, according to the prospectus. Located one mile from the statehouse, Cadwalader Place received twice-a-day mail delivery and was near both railroad and trolley stops. The six city-block area that comprises Berkeley Square was home to industrialists, upper management, doctors, and lawyers.

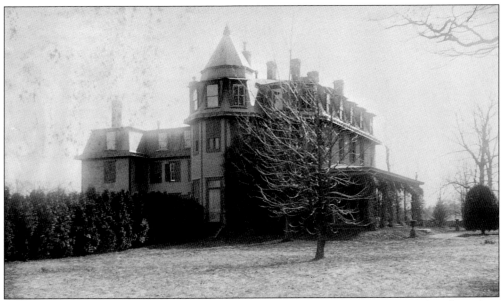

THE CADWALADER MANSION, c. 1890, 924 WEST STATE STREET. From the mid-18th century to the end of the 19th century, Cadwaladers figured in the history of the city. Descendants of Dr. Thomas Cadwalader chose to sell their Trenton properties in the mid-1800s. In the 1924 City Directory, there is a listing for a Mary Cadwalader in an apartment at 924 West State Street. The house shown here has been razed and replaced with a modern home, out of place with its Victorian and Edwardian neighbors.

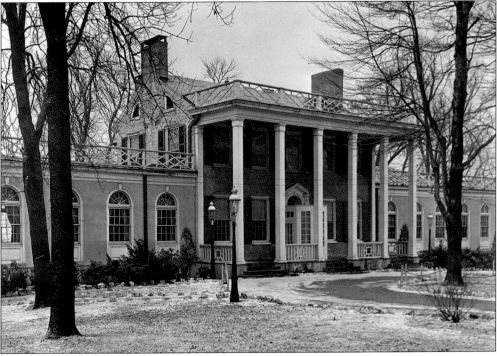

THE TRENTON COUNTRY CLUB, 1940. The Trenton Country Club was founded on Ferdinand Roebling's farm on the western edge of town. The clubhouse, Oaklands, was erected in 1940.

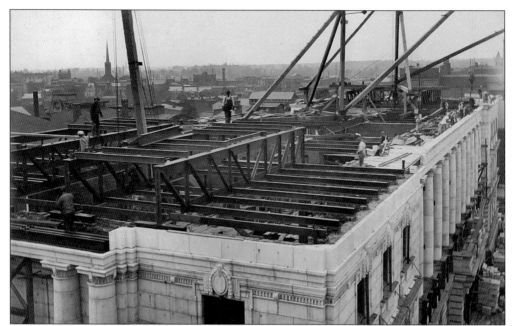

THE CONSTRUCTION OF CITY HALL, 1909, EAST STATE AND STOCKTON STREETS. In 1906, the Trenton Common Council voted to build a new, more modern and spacious building for conducting the City's business. The building at Broad and State Streets was bursting at the seams due to industrial and population booms. Ferdinand W. Roebling, Gen. C. Edward Murray, and Jonathan H. Blackwell were named to the Trenton City Hall Building Commission and soon decided to place a three-story building at East State and Stockton, next to the State Armory Building. The cornerstone was laid in 1909 and opened in November 1910. Following the destruction of the armory by fire in the 1970s, a three-floor annex was added to city hall.

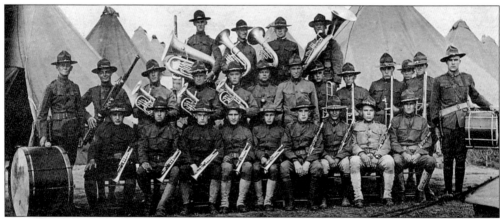

THE 2ND REGIMENT BAND, N.J. INFANTRY, AT CAMP DONNELLY. Trenton prepared for war, and when Pres. Woodrow Wilson called for an emergency force, the first New Jersey soldiers were mobilized here in March 1917. Camp Donnelly, named for the city's mayor, was built on Brunswick Avenue. From here, troops were sent first to Sea Girt and then to Camp McClellan in Alabama. Trenton's men were shipped to Europe in June 1918. Others replaced them in the camps and in total, Trenton sent 5,200 men to serve America's interests. Of those, 148 did not return.

A World War I Soldier. Trenton sent hundreds of young men when America joined WWI in 1917. The town followed the soldiers' activities closely through army press releases and through letters graciously provided by soldiers' mothers.

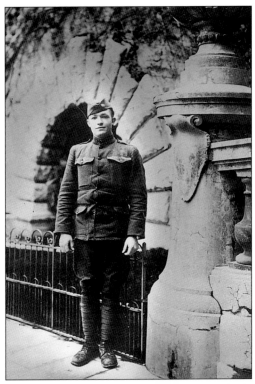

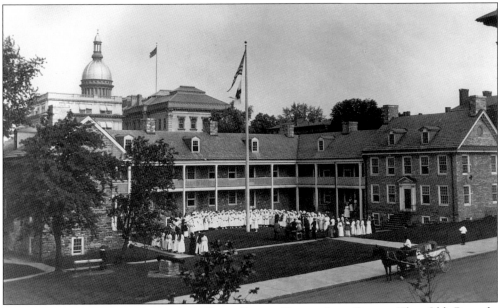

The Graduation of the 1918 Red Cross First Aid Class. The Old Barracks changed over time, and at one point a section was removed to continue Front Street to the statehouse. Immediately after the Battle of Trenton the building served as a military hospital; afterward, it was used as private housing, a schoolhouse, and a home for widows and orphans. During WWI, the building was used for the training of a different type of soldier—hometown nurses also served.

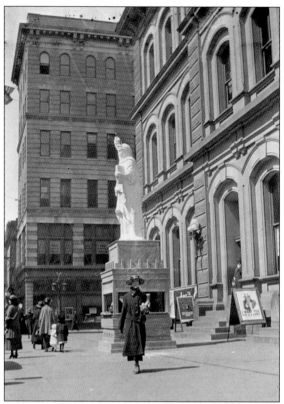

VICTORY LOAN STATUE, WORLD WAR I. A replica of the Statue of Liberty stood in front of the U.S. post office on East State Street. This statue was unique: its base opened as a kiosk for the selling of Liberty Loan bonds. There were four Liberty Loan campaigns and one campaign for Victory Loans. This picture dates from 1919.

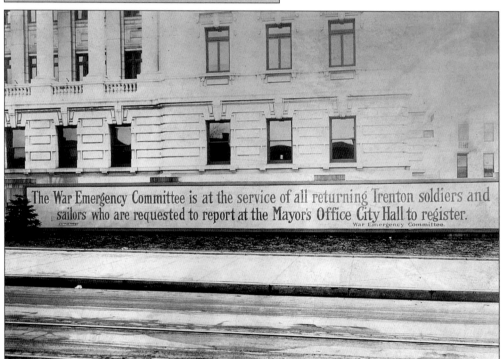

CITY HALL. Trenton welcomed home veterans of WWI with a fatherly hand of assistance.

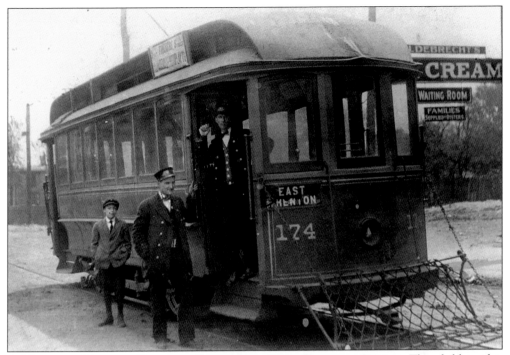

A TRENTON TRANSIT COMPANY STREETCAR, EAST TRENTON ROUTE. The child in this photograph is identified as William Thorton, later chief dispatcher for Trenton Transit. The gentleman in front is noted as his father, and standing in the train is Edwin E. Watkinson. The net in front of the train scooped debris from the trolley tracks.

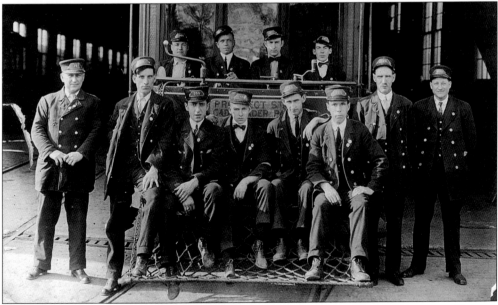

THE PROSPECT STREET–CADWALADER PARK TROLLEY. The most distant points in Trenton could be reached by the trolley system. A complicated series of tracks converged at State and Broad Streets in overlapping cloverleafs. In the late 1980s, the city completed the removal of all tracks.

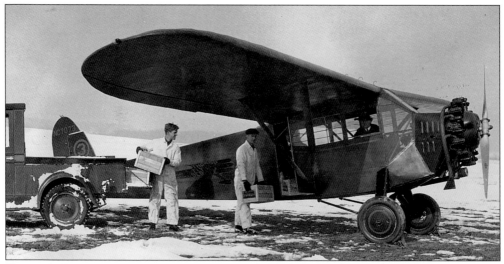

THROPP'S FLYING SERVICE. Progress moves in leaps and bounds. Crates of Borden's milk are being loaded into the plane. Small airports and companies survived in the fledgling business by moving materials such as milk and the U.S. mail. Regional commercial freight and passenger services have gravitated toward the Trenton-Mercer Airport in nearby West Trenton.

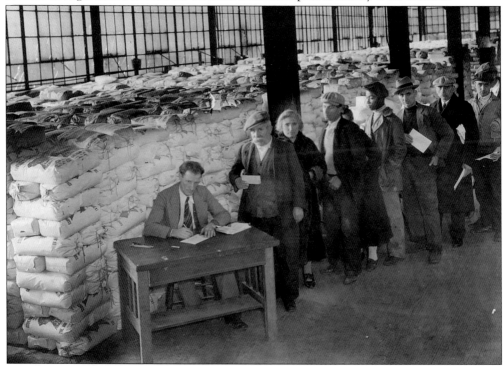

QUEUING FOR FLOUR AT THE THROPP FACTORY. Unemployed Depression-era Trentonians joined lines for bread, clothing, and, as seen here, sacks of flour. The Works Progress Administration (WPA) put men to work at the Trent House and along the canal and river. The power of this devastating time in our history is told in this and other photographs in the Trentoniana Collection at the public library. The depth, height, and length of these stacks of sacks are overwhelming, yet the flour in them provided only the bare minimum of subsistence.

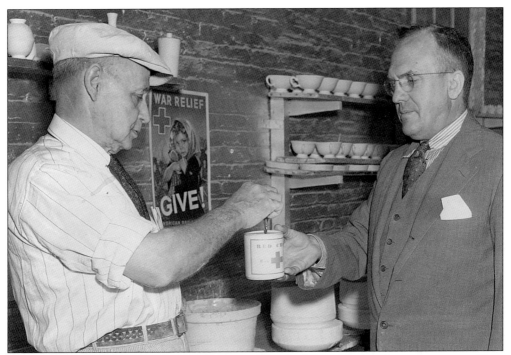

GIVING FOR WAR RELIEF. If you could not get to the Red Cross, its members came to you. Here a local potter contributes to a WWII victims relief fund.

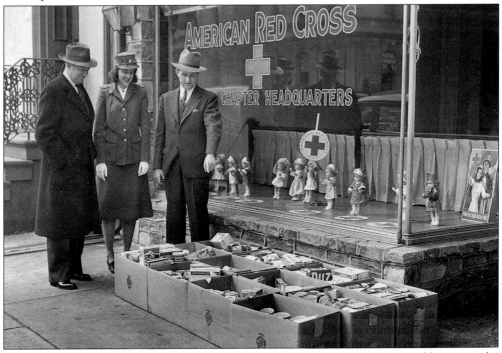

CANNED AND HOUSEHOLD GOODS. An unidentified WWII servicewoman and her comrades view contributions to a war relief drive. Note the ornate iron railing to the left; much of Trenton's ornate ironwork was torn out during WWII and given away during scrap metal drives.

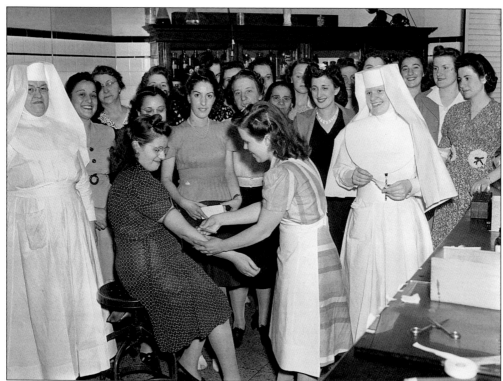

THE RED CROSS AT ST. FRANCIS HOSPITAL. Here we see brave volunteers attending a WWII blood drive. During both World Wars, the citizens of Trenton contributed to the war efforts, even if it meant rolling up a sleeve and holding an arm out to a young woman in a striped dress and white apron.

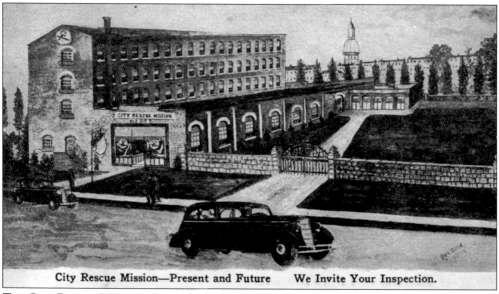

City Rescue Mission—Present and Future We Invite Your Inspection.

THE CITY RESCUE MISSION. Formerly the home of Maddock's Pottery, this building continues to serve the Trenton community as the home of the City Rescue Mission. The building underwent restoration in the late 1900s.

Three

CELEBRATIONS AND CIVIC EVENTS

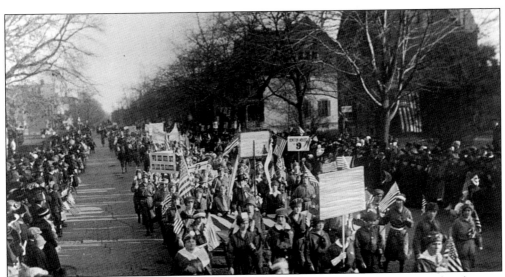

CELEBRATIONS AND CIVIC EVENTS. In our fast-moving lives, we may forget that historic events, be they global, national, or local, were not experienced through a box or screen in the den. Citizens embraced the end of war and celebrated in the streets. History was represented through allegoric pageants and displays. A political visit was seen as a great occurrence in the life of a town.

When an important visit came, such as the Grand Army of the Republic encampment seen in this chapter, citizens were kept informed of preparations and schedules. No detail, no matter how minute, escaped the eye of the press, which reported every bit. The pictures that follow are a small representation of events that captured the attention of Trentonians.

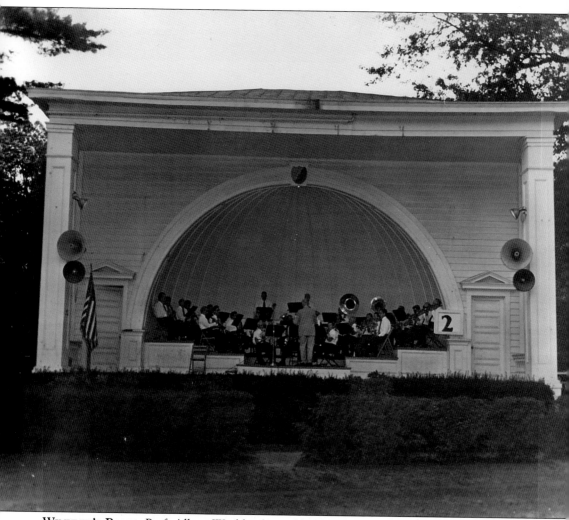

WINKLER'S BAND. Prof. Albert Winkler formed his band in 1874. For the next 14 years, the band performed on many occasions, including the dedication of Grant's Tomb in New York, in front of Pres. Chester Arthur during a GAR convention, and on parade with the Trenton volunteer fire companies. In 1888, Winkler embarked on a series of summer concerts in Cadwalader Park. An individual, a firm, or a local organization paid for each concert. Shortly after Trenton turned to a commission form of government in 1911, the concert series became a line item in the City's budget. The popular summer series continued for many years following Winkler's death in 1922.

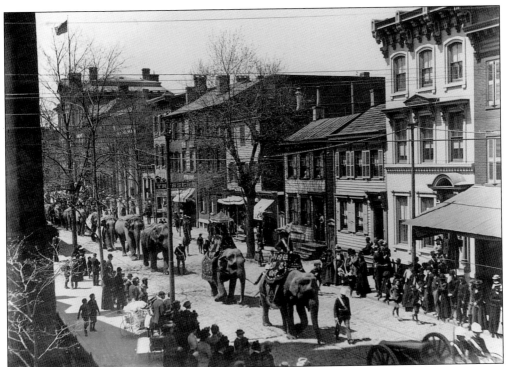

BARNUM'S CIRCUS. The circus is traveling through the streets of Trenton on the way to city hall, drumming up business as the elephants lumber along. The City frequently rented out the second-floor hall for visiting events. W.W. Cole and his Famous New York and New Orleans Circus, Museum, Menagerie, and Congress of Living Wonders brought the first electric illumination and American-born giants Martin and Anna Bates to Trenton.

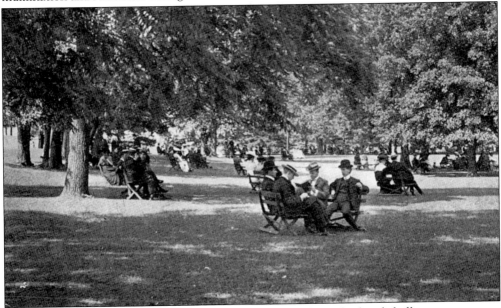

CADWALADER PARK. Imagine the lilting music floating from the band shell as you converse with friends under the spreading arms of leafy shade trees.

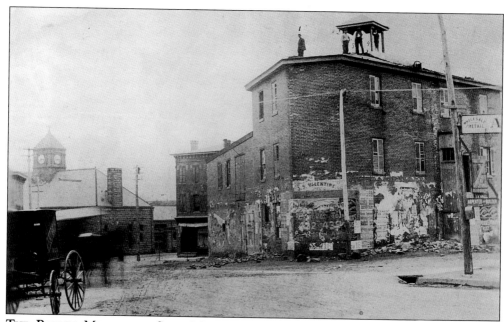

THE BATTLE MONUMENT SITE, MARCH 31, 1891. Make way for the new monument to celebrate Washington's first victory at Trenton! This picture, taken on March 31, 1891, at 8:15 a.m., shows tinsmith George V.D. Voorhees, druggist F. Sullivan, T. Brady, and Charles B. Schnell as they begin dismantling the roof of the Valentine Blacksmith and Wagon Works. Five roads converge at this point, marking the northern boundary of William Trent's village. It was here, following a predawn march along the Pennington Road, that Washington set up his artillery, which rained cannon shot down two of Trenton's roads, startling and outmaneuvering 900 Hessian and British soldiers.

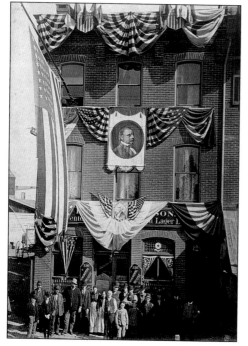

DEDICATION DAY FOR THE BATTLE MONUMENT. The Monument Hotel took its name from the slender column rising in front of it. Finally, dedication day, October 19, 1893, arrived, and these onlookers positioned themselves for an excellent view of the ceremonies.

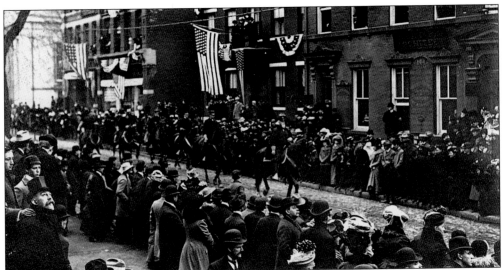

THE REENACTMENT OF THE BATTLES OF TRENTON, DECEMBER 1901. The highlight of the holiday season in Trenton is the annual reenactment of the Battles of Trenton, a tradition that, until recently, had fallen out of style. It is delightful to see the battles staged today, as they were on the 125th anniversary celebration, in the very streets where they occurred. The roar of the cannon, the white clouds of smoke drifting from the musket barrels, and the sight of a city bus surrounded by redcoats all invoke patriotic spirit.

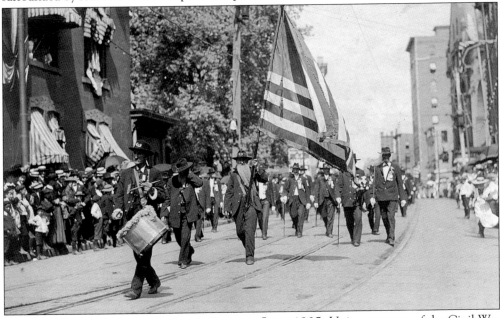

THE GRAND ARMY OF THE REPUBLIC PARADE, JUNE 1905. Union veterans of the Civil War organized the Grand Army of the Republic in 1866. New Jersey veterans quickly applied for and received permission to form the Department of New Jersey. In 1905, their ranks thinning, they held a grand encampment in Trenton. Events included this parade, beginning at 2 p.m. on June 22, 1905, followed by a concert and baseball game at Cadwalader Park. The festivities ended with a campfire at the Taylor Opera House and a brilliant electrical display and illumination of the city.

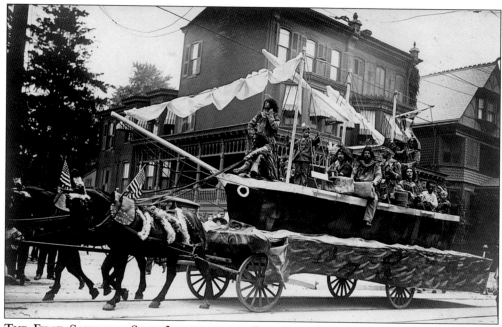

THE FIRST SAFE AND SANE INDEPENDENCE DAY PAGEANT, 1910. On July 5, 1910, the evening edition of the *Trenton Times* reported, "Fourth Celebrated in a Way That Does City Great Credit." The subtitle stated, "Splendid Street Pageant of Educational Worth Replaces Noisy, Dangerous Demonstration of Other Years." According to the article, Trenton joined other American cities in quashing the "noisy, death-dealing, and maiming celebration" of recent years.

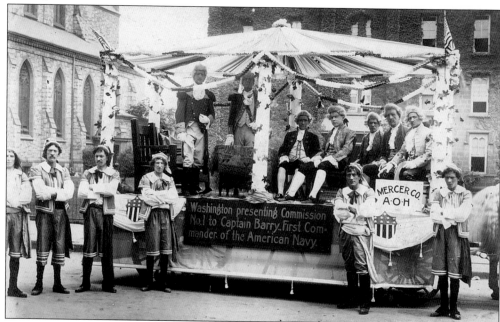

THE MERCER COUNTY ANCIENT ORDER OF THE HIBERNIANS FLOAT, JULY 4, 1910. Washington presents his commission to Captain Barry, the first commander of the American navy. It should be safe to assume that Barry was either an Irishman or an Irish-American.

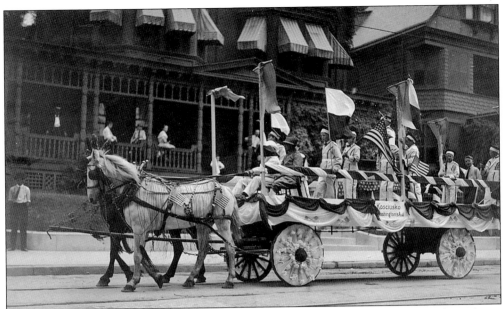

THE ST. STANISLAUS SCHOOL FLOAT, JULY 4, 1910. In celebrating America's Independence Day in a safe and sane manner, St. Stanislaus students and faculty chose to present *Taddeus Kosciusco*, a play about the great Polish soldier who brought order to Gen. George Washington's ragtag soldiers. Through the long winters in Valley Forge, Kosciusco drilled the patriots repeatedly, instilling pride as well as discipline and synchronized shooting skills in the farmers and townsmen who made up the American forces.

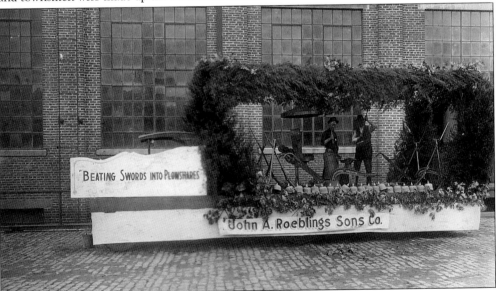

THE VICTORY PARADE, ARMISTICE DAY, 1918. The people of Trenton celebrated the end of WWI, "the war to end all wars," with a parade that Mayor Frederick W. Donnelly declared would be "the greatest demonstration in history." Some 45,000 people marched from the northeastern part of town to the western edge and then to the downtown area and east to Chambersburg and finally to South Broad Street. The *Trenton Times* issued an early evening edition so that its employees could participate in the parade.

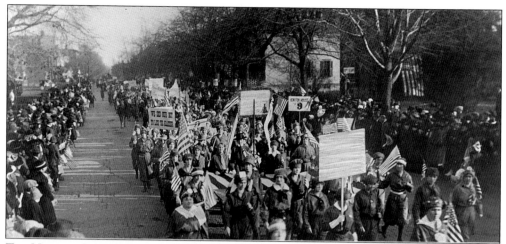

The Normal School Joins the Parade. Every group that could celebrate victory did so. The Trenton Normal School first opened in 1855 with the object of having students learn the model practices in school teaching and management. The school was separated into the Normal, or training, School and the Model School, where students observed the work of practicing teachers working with elementary and secondary-aged children. In 1929, the school charged no tuition to a student agreeing to work for two years in a New Jersey school. The institution's name had changed to the State Teachers' College and State Normal School at Trenton. Later, the name was changed to Trenton State College and then to the College of New Jersey.

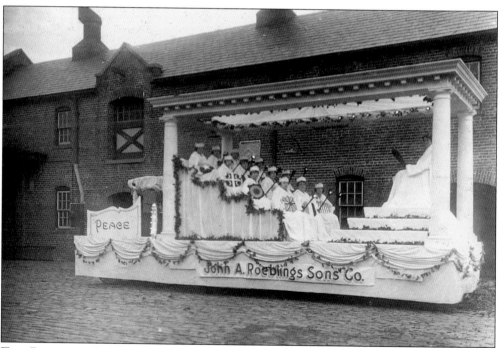

The Roebling Company Floats. Roebling contributed two floats to the Armistice Day celebration. One was the the biblically referenced "Beating Swords into Plowshares" float. The other was this one, which symbolizes the finally realized dream of the end to the European conflict: white-robed women holding what is probably the shining light of peace.

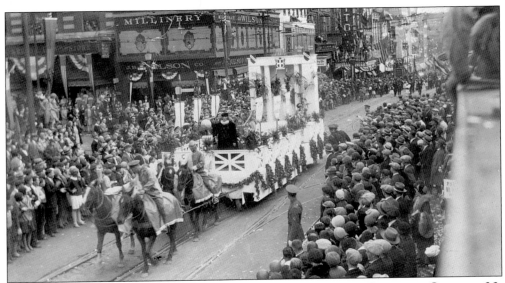

THE QUAKER SETTLEMENT OF TRENTON'S 250TH ANNIVERSARY PAGEANT, OCTOBER 30, 1929. While fortunes were plummeting on Wall Street, Trenton was celebrating its 250th birthday with a week full of anniversary events. A magnificent pageant took place on October 30, 1929. Pageant director Rev. Hamilton Schuyler told readers of the *Sunday Times Advertiser* that $40,000 had been spent on the floats. Led by pageant marshals, honored guests, and a band, the first float featured Lenni Lenape Chief War Eagle, gazing out on the rock-strewn, flowing waters of the Delaware River. The fourth float depicted Quaker settlers at the Ffalles of the De La Warr. Five divisions of floats, bands, and marchers presented the 14th float, "Father Trent and the Nine Civic Muses—Education, Art, Religion, Good Government, Industry, Public Health, Commerce, Independent Press, and Transportation."

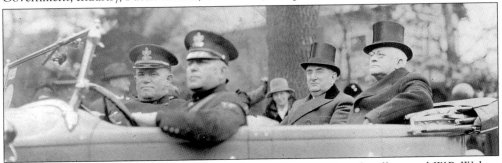

THE 250TH ANNIVERSARY CELEBRATION. George Eaton, police chauffeur, and W.P. Walter, police chief, drive Mayor Frederick W. Donnelly and James Kerney, owner of the *Trenton Times*, through the parade. Donnelly was mayor from 1911 to 1932—21 years, through WWI, the Jazz Age, and the early years of the Depression. He retired to care for his business interests following the death of his son. Among his many achievements for Trenton was the creation of a deepwater channel and marine terminal, allowing Trenton to be considered a seaport town. Donnelly also drove the development of the Municipal Colony hospitals, and the complex was renamed in his honor following his death in 1935. Kerney, through the newspapers he published—the *Trenton Evening Times* and the *Sunday Times Advertiser*—was generous in his contributions to the city's progress and welfare. He created several scholarships and funds for children that the *Times* has continued for the past century. A friend and adviser to Gov. (later Pres.) Woodrow Wilson, Kerney served the city, state, and nation on many different occasions.

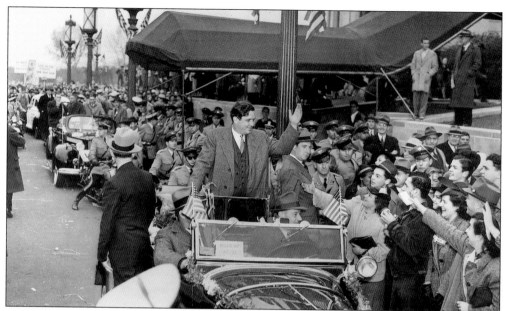

WILLKIE FOR PRESIDENT. This photograph shows the side entrance to the War Memorial, October 31, 1940. Since its construction, the War Memorial has had several national campaigns in its front court. Wendell Willkie, Dwight Eisenhower, and John Kennedy are just some of the presidential hopefuls who brought their message to the citizens of Trenton.

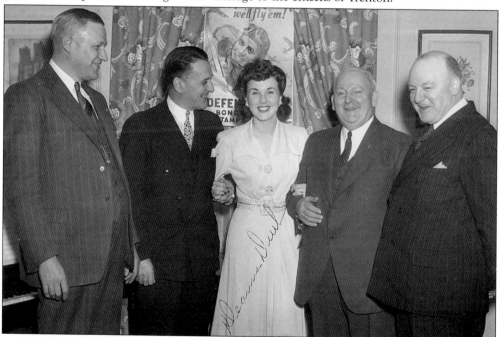

DEANNA DURBIN, MOVIE ACTRESS. The *State Gazette* of February 18, 1942 highlighted the arrival of movie actress Deanna Durbin in Trenton. Staying in a suite at the Stacy-Trent Hotel, the actress came to "endorse the 'Trenton Plan' for the sale of defense bonds and stamps" and participated in a "monster parade" to kick off the bond drive. The four beaming gentlemen are members of the City Commission.

Four

INSTITUTIONS

TRENTON'S INSTITUTIONS. Public buildings, schools, and government are all institutions that come to mind quickly. Trenton's institutions are more diverse. Homes, such as Trenton's row houses and the large mansions of industrialists, are part of the city's fabric as are neighborhoods, organizations, and individuals. Here is a glimpse at just a few of Trenton's many institutions.

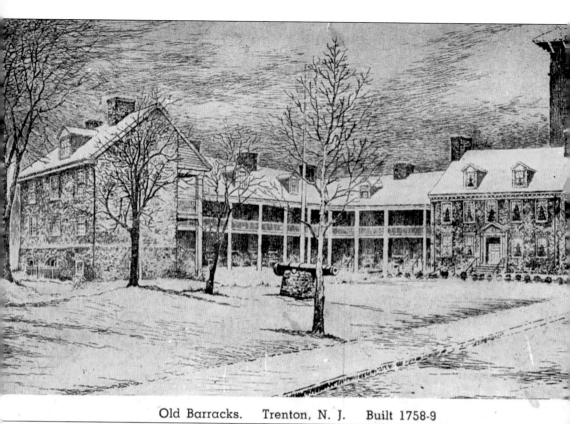

Old Barracks. Trenton, N. J. Built 1758-9

THE OLD BARRACKS. A group of Trenton matrons created the Old Barracks Association and in 1911, purchased one wing of the old building. They convinced the State to purchase and restore the entire property, including rejoining the portions of the structure torn apart for the continuation of Front Street to the capitol. The restoration was done to suit Colonial revival- era sensibilities. The two parties then entered a unique agreement that allowed the site to be administered by the association, with ownership and maintenance in the hands of the State. From 1996 to 1998, a more accurate restoration was conducted, which involved extensive archaeological investigation. Research showed that the roof had been wood shakes and the balcony was cantilevered off the roof. This indicated the replacement of the revival-era slate roof and the column-supported balcony, as well as the relocation of the main doors and the lowering by several feet of the parade ground, the yard contained within the U shape of the building.

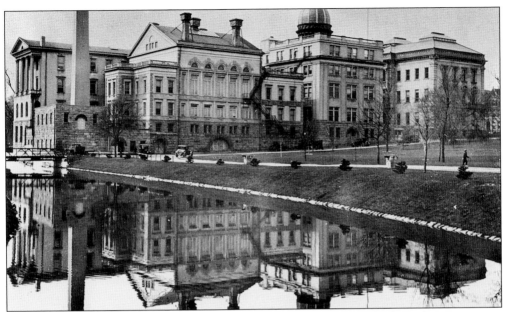

THE STATEHOUSE, REFLECTED ON THE CANAL. This photograph dates from sometime between 1912 and 1917. Woodrow Wilson, former president of Princeton University, served as New Jersey's governor from 1911 to 1913, when he took up residence at 1600 Pennsylvania Avenue, Washington D.C. Wilson's lieutenant governor, James F. Fielder, completed Wilson's term and in 1914, took up the reins of the State government. Fielder was succeeded by Gov. Walter E. Edge.

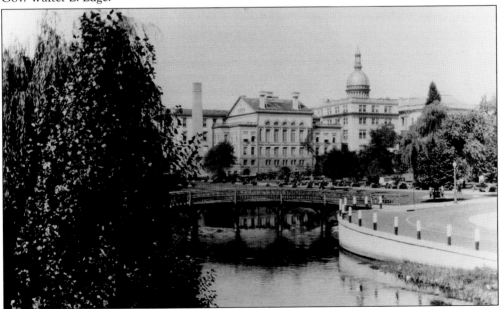

THE STATEHOUSE FROM STACY PARK. Mahlon Stacy Park runs along the Delaware River from just east of the statehouse to the Island, a Trenton neighborhood along the river at the western edge of town. Designed by Frederick Law Olmsted in 1884, the park was not fully realized until the 1910s. Construction of the John Fitch Way (today's Route 29) in the 1950s destroyed parts of Stacy Park, including this lagoon. Plans exist to restore some of these lost sections.

THE CHILDREN'S HOME SOCIETY, 1865–1877. This society, comprised of prominent New Jersey women, was originally formed to provide care and education for destitute orphans of the state's Civil War soldiers. The society's work, begun at the end of the Civil War, continues today with services for families and the placing of adopted children.

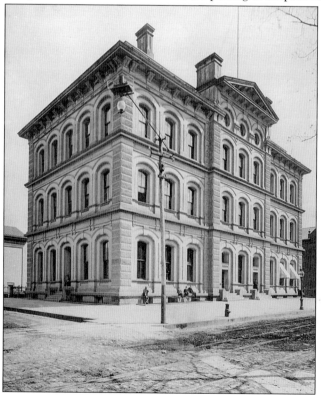

THE U.S. POST OFFICE. Built in 1876, the post office building actually served as Trenton's first federal building. It held both the federal courts and the mail. The building came down in the early 1960s, replaced by a small branch office of the Broad Street Bank. Trenton's first post office was built in 1753 and served as a schoolhouse.

THE GEORGE WASHINGTON STATUE, CADWALADER PARK. Private funds were used to purchase this statue of Washington, shown in command at the bow of his Durham boat on December 25, 1776. Originally commissioned for the centennial celebration of the U.S. Constitution, the statue stands 14 feet high and is sculpted from a single piece of Italian Carerra marble weighing 7 tons. Trenton purchased the statue for $300 and had it installed at the newly created Cadwalader Park. In 1976, as part of the bicentennial celebration of the Declaration of Independence, the statue was moved to Mill Hill Park. Two fading index cards from 1892 state that the pictured gentlemen are members of the Junior Order of United American Mechanics. Shown are, from left to right, the following: (front row) C. Sleve, C. Clayton, J.E. Glenn, G.W. McFarland, E. Johns, W.J. Blackford, J.D. Rice, and C. Severns; (back row) W.H. Abbott, T.H. Heron, C. Neunann, W. Anderson, W. Gibson, H. Naylor, H. Wolf, and A. Bailey.

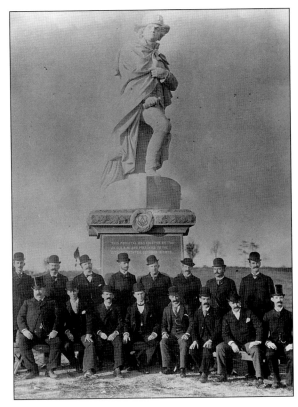

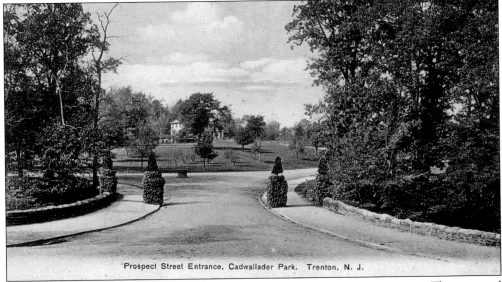

Prospect Street Entrance, Cadwallader Park. Trenton, N. J.

SCENIC POSTCARD SHOWING THE MAIN ENTRANCE TO CADWALADER PARK. This postcard mistakenly identifies the entrance to Cadwalader Park as located on Prospect Street. The correct location is Parkside Avenue, which was built at the same time as the park.

THE GROUNDS OF THE MUNICIPAL COLONY. Mayor Frederick Donnelly, the Sanitary Committee, the Poor Committee, and the Board of Health worked together to replace the old pesthouses with this hospital facility. The hospital came about as the result of a 1904 outbreak of the pox. Having nowhere to house the poor and indigent who were suffering from this illness, the City resorted to shacks on these grounds on the outskirts of town.

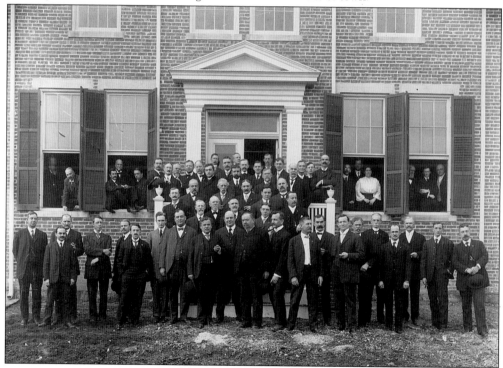

THE DEDICATION OF THE SMALL POX HOSPITAL. On December 29, 1906, these men dedicated the first in a group of five hospitals to be built on land just outside the city limits. In a very short time, the building was expanded and modified to become a tuberculosis hospital. After Mayor Frederick Donnelly's death, the colony was renamed the Donnelly Memorial Hospitals. The facility ended its service to Trenton in the 1970s as a senior care facility.

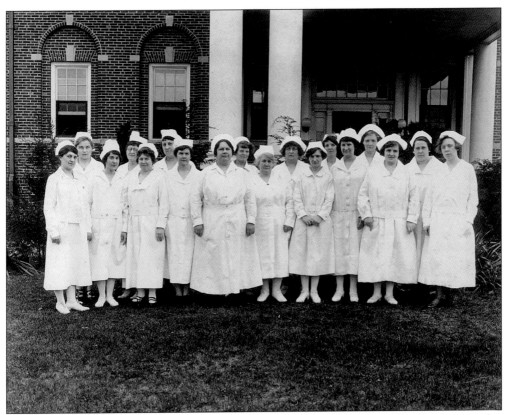

NURSES AT THE MUNICIPAL COLONY. Notice the old-fashioned hats worn by the nurses in this photograph, taken *c.* 1924.

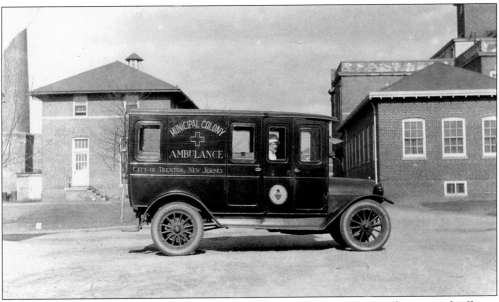

THE MUNICIPAL COLONY AMBULANCE. Here, the ambulance rests, ready to speed off at a moment's notice to a nearby emergency.

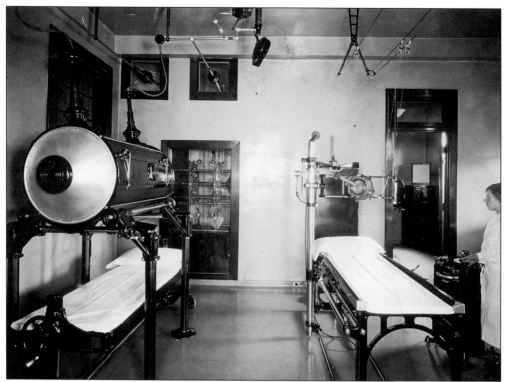

THE MUNICIPAL COLONY X-RAY ROOM. The X-ray room looks immaculately clean in this photograph, taken in 1927.

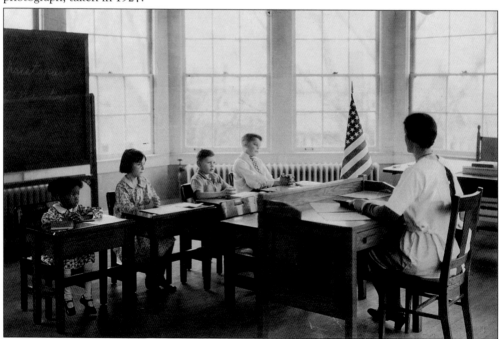

A MUNICIPAL COLONY SCHOOLROOM, 1930. This sunny schoolroom was located in the Tuberculosis Hospital.

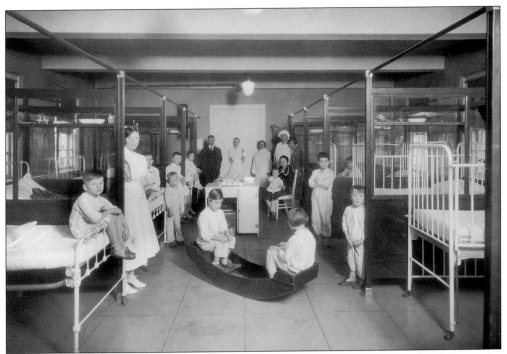

SCARLET FEVER CONVALESCENTS. The Contagion Hospital is one of the five buildings on the grounds of the Municipal Hospital.

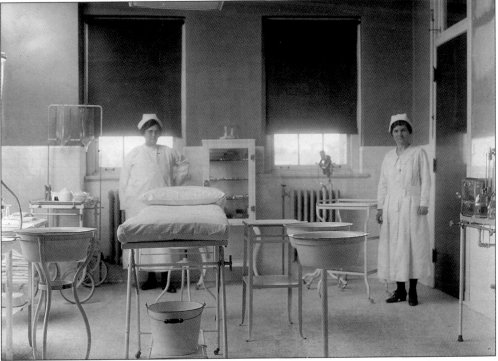

AN OPERATING ROOM AT MUNICIPAL COLONY. Much like the X-ray room, this operating room is spotless. The two nurses stand ready to assist with the next procedure.

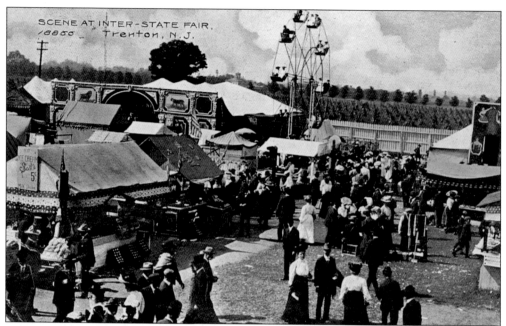

THE INTERSTATE FAIRGROUNDS. Trenton's first interstate fair was held by the Mercer County Board of Agriculture in 1885. In 1888, the Interstate Fair Association was formed. Horse racing was the primary interest of association founders. John Taylor, owner of the Taylor Opera House, was the first president, with many of Trenton's leading businessmen following him in this position. At first, produce, livestock, and agricultural education programs were available for fair goers and, over time, more familiar fair events such as the auto exhibit, the carnival, the airplane demonstrations, and the food vendors were added.

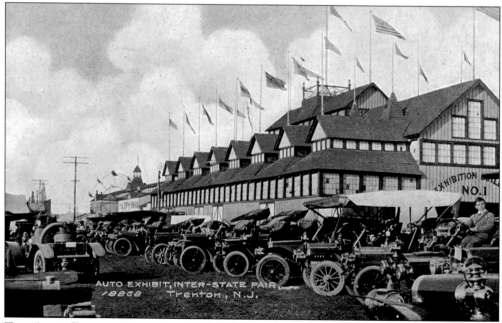

THE AUTO EXHIBIT FAIRGROUNDS. People crowded into the fairgrounds to see the proud owners show off their automobiles.

TIGE, THE HARMONY FIRE COMPANY MASCOT. The Harmony Fire Company volunteers, including mascot Tige, served the needs of residents and businesses above the feeder canal. Created in 1849, it continued until 1892 when a citywide fire department came into being.

THE HARMONY FIRE ENGINE COMPANY. Tige sits next to the driver, ready to respond to an emergency or to participate in a firemen's parade, as shown here. The company was located at Warren and Tucker Streets.

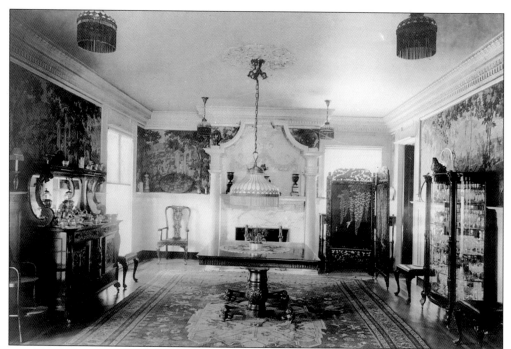

THE R.V. KUSER HOME DINING ROOM, 315 WEST STATE STREET. This dining room and the music room shown in the accompanying photograph provide a glimpse into the mansions of West State Street. Many homes, including this one, have been converted into office space. Edison State College currently owns the Kuser House.

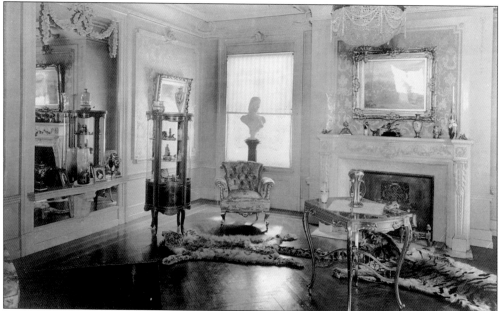

THE MUSIC ROOM. R.V. Kuser had fingers in many pies. In addition to being president of the Peoples Brewing Company of New York and Trenton, he also served as vice president of Lenox Inc., vice president and director of the First Mechanics National Bank, director of the Standard Fire Insurance Company, and president of the Interstate Fair Association.

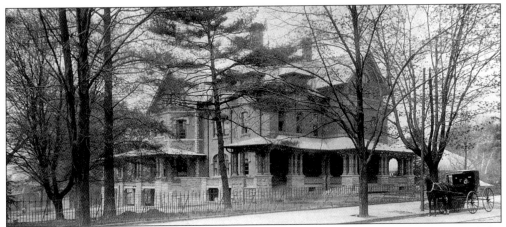

THE HOME OF CHARLES G. ROEBLING, 333 WEST STATE STREET. While many of the imposing town homes of Trenton's business owners remain on the blocks of West State Street, others, such as the two homes of the Roebling brothers, were razed. An apartment building now stands on this site. After graduating from Rensselaer Polytechnic Institute, Charles Roebling joined the business in 1871, working alongside his father's right-hand man Charles Swan. He soon replaced Swan and managed the day-to-day operations of the business, while elder brother Ferdinand Roebling handled sales and finances. While building the Brooklyn Bridge, eldest brother Washington Roebling resigned the company's presidency. Charles Roebling, the natural successor, held the post until his death in 1918. His son Washington Roebling II died aboard the *Titanic* in 1912. It is said that the father never recovered from the news; the memorial above Charles Roebling's grave contains a cenotaph commemorating his son's tragic life.

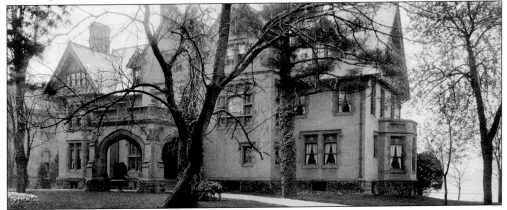

THE HOME OF WASHINGTON AND EMILY ROEBLING, 181 WEST STATE STREET. Brooklyn Bridge builder Col. Washington Roebling and his wife, Emily Roebling, built this grand residence a few short yards from the statehouse in 1892. In 1921, at the age of 84, Roebling came out of retirement to assume command of the John A. Roebling's Sons Company after the death of his nephew Karl Roebling, then president of the company. For five years, until his death on July 21, 1926, Roebling continued to expand and strengthen the company that he and his brothers had built into the largest wire rope manufacturer in the world. As president of the Roebling Company, his role in Trenton was unquestioned. For example, there was no trolley stop in front of his mansion, yet the trolley stopped when the colonel stood at his gate; and, while no dogs were allowed on the trolley, an exception was always made for Roebling's Airedale. The house was razed in the 1940s to make way for the state library.

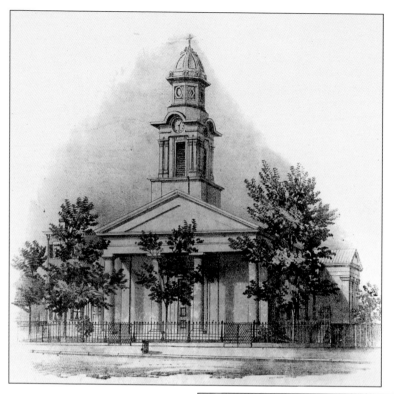

THE CHAPEL OF ST. JOHN THE BAPTIST ROMAN CATHOLIC CHURCH. St. John's was the first Catholic church in New Jersey, being dedicated in 1814 to serve Trenton's Irish, French, and German Catholics.

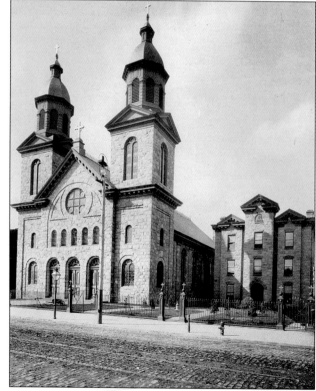

THE SACRED HEART ROMAN CATHOLIC CHURCH. Located on the corner of South Broad and Centre Streets, Sacred Heart was built soon after St. John's was destroyed by fire in September 1883. The building was dedicated on June 3, 1889.

THE SWAMP ANGEL. This cannon stood in the middle of busy Perry Street until its removal to Cadwalader Park. The Swamp Angel took part in the Civil War in August 1863, when it fired 36 shots at St. Michael's Church in Charleston, South Carolina. Union Gen. Quincy Gillmore, who had demanded the immediate evacuation of rebel positions on Morris Island and Fort Sumter, ordered this action. The gun was later purchased by Trenton when it was sold as scrap iron; the cannon had broken on the 36th shot.

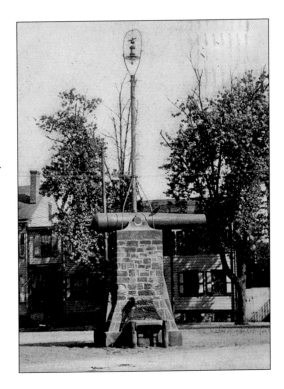

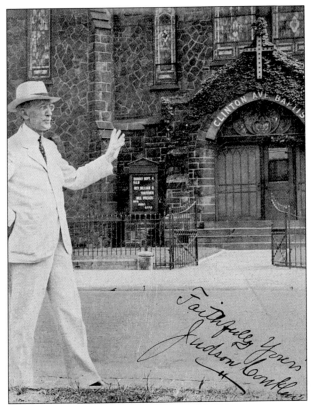

THE CLINTON AVENUE BAPTIST CHURCH, 1925. Formed in 1867, the Clinton Avenue Church, seen here, was built in 1876. The Reverend Judson Conklin was the fourth minister of the church, serving from 1885 to 1926. He increased membership from 75 to 800 and during his tenure, a large chapel was erected, the interior of the church was remodeled, and a pipe organ was installed. This photograph was taken one year before Conklin retired.

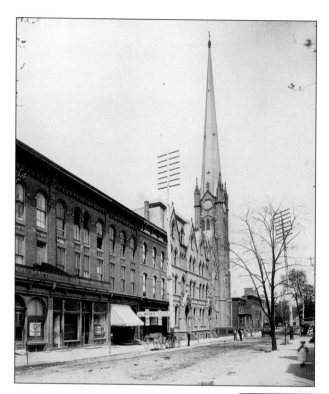

ST. MARY'S ROMAN CATHOLIC CHURCH. St. Mary's is located at the corner of North Warren and Bank Streets. It was built in 1866–1871 to serve the Catholics living north of the Assunpink Creek. By 1881, St. Mary's was, and continues to be, the See of the Diocese of Trenton. The 256-foot spire shown here was built in 1878 and was removed because of safety issues in 1953.

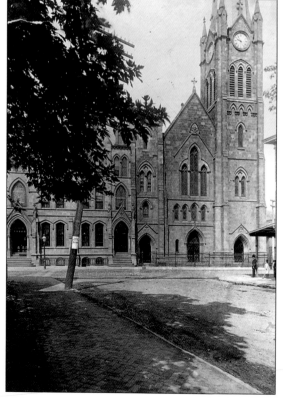

ST. MARY'S AS VIEWED FROM PERRY STREET. Bank Street turns into Perry Street as it crosses North Warren Street. This picture, taken from Perry Street, shows off the front facade, including the diocese office to the right of the tree. The bishop's residence, the first doorway at the far left, was later changed to a large home in the Berkeley Square Historic District.

The Fourth Presbyterian Church. This church is located at the corner of South Clinton and East State Streets. On November 6, 1858, 51 communicants of the Third Presbyterian Church formed the Fourth Presbyterian. The church building was dedicated on October 16, 1862. The steeple rose 229 feet above the roof of the church and was the tallest point in the Trenton skyline. The majestic spire fell to the ground in 1870. Snapped off at 20 feet above the roof by wind, the spire destroyed the flagstones of the pavement below. This photograph shows the replacement spire that was later removed due to the costs of maintaining it.

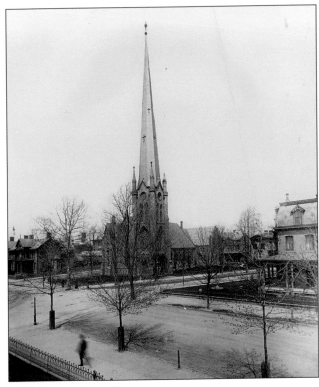

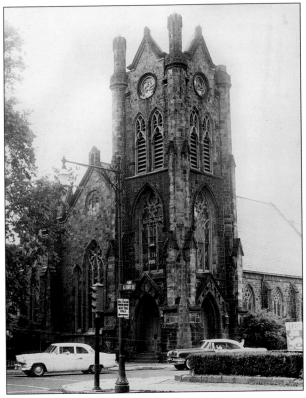

Today's Fourth Presbyterian Church. This photograph, taken *c.* the early 1960s, shows the building that the people of Trenton know today.

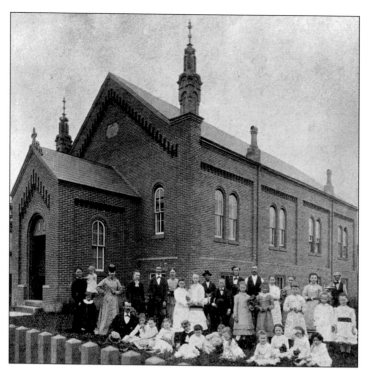

THE HAMILTON AVENUE METHODIST CHURCH. At the corner of Hamilton Avenue and Hudson Streets, this church was dedicated on March 2, 1873. It provided a house of worship for the growing number of Methodists in the Chambersburg area. By 1893, the building had grown too small for the congregation and a new brownstone church was erected. This picture shows participants at an Easter Monday picnic.

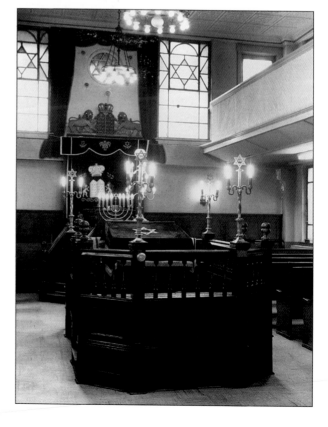

THE WORKERS OF TRUTH, 32 UNION STREET. The Workers of Truth incorporated in 1919, becoming the fifth Jewish congregation in Trenton. The first, Har Sinai Hebrew Congregation, began regular services in 1860. The Workers of Truth purchased and converted two houses on Union Street into a house of worship.

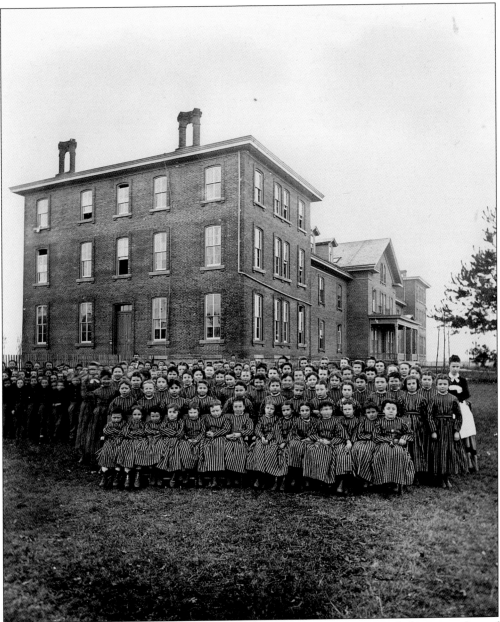

THE HOME FOR SOLDIERS' ORPHANS, HAMILTON AVENUE, 1883. A large number of children were left fatherless by the war against the South. Following the last child's move into self-subsistence, the Children's Home Society returned this structure to the State. It was used to house the school for New Jersey's deaf. Evolving into the Katzenbach School for the Deaf, the orphanage was replaced with a lovely campus on Trenton's western border.

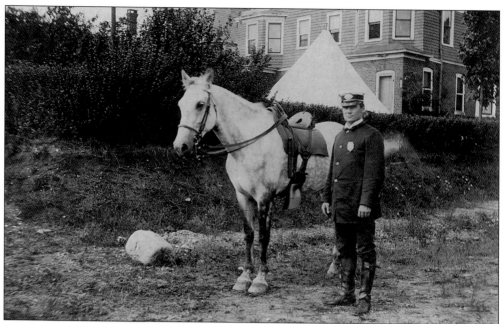

POLICEMAN JACK DEVANEY. Jack DeVaney was with the Trenton Police Department in 1895, when it purchased five horses and housed them in a stable at the back of the First Division Station. This picture is dated 1906. Mounted patrolmen moved on to automobiles and in 1919, the horses were sold. Lieutenant Thief and Sergeant Stanley were the last officers to ride horses.

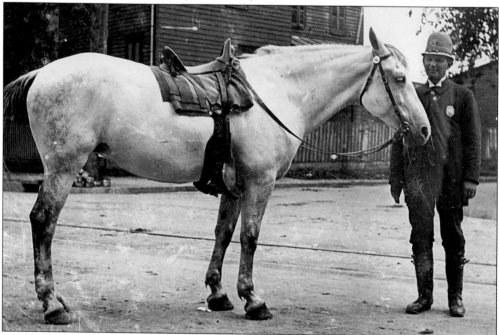

ANOTHER OF TRENTON'S FINEST. Through means of the weekly meeting, the Quakers had managed law enforcement in Trenton. The town's growth spurred the election of a town marshal and constable by 1792. In 1814, the city marshal received $30 annually for his efforts. Trenton's modern police department came into being by Common Council ordinance in 1874.

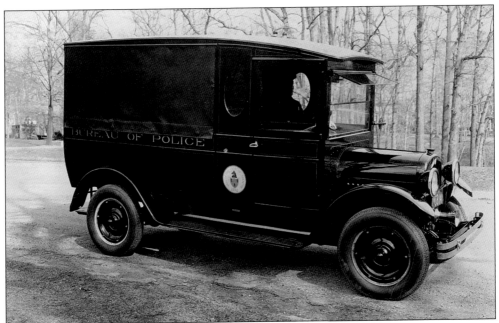

AN EARLY PATROL WAGON. As the city's 250th anniversary approached, Trenton was proud of its thoroughly modern police department. The department's vehicles included three combination patrol wagon-ambulances, capable of holding prisoners or transporting three injured persons. Nine drivers were employed in three eight-hour shifts. Also in the fleet were a bandit-chasing car, special autos for the detective bureau, and a towing machine.

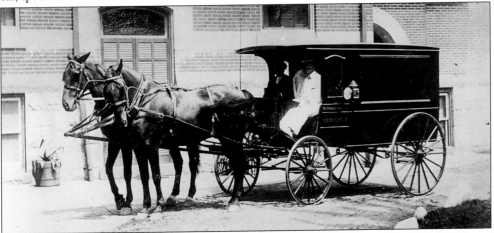

ST. FRANCIS HOSPITAL'S AMBULANCE. In 1870, Sr. Mary Hyacintha of the Third Order of St. Francis purchased land for the city's first hospital. She and three other nuns had come to Trenton a few years earlier to develop a school missionary. They quickly realized that Trenton would receive more benefits from a hospital. Reaching out to the ill and dying, the nuns at first went from home to home dispensing care. Sr. Mary Hyacintha had raised $500 toward the cost of the desired land and required $1,300 more to meet the asking price. Fortunately, landowner Samuel K. Wilson donated the very amount needed. The community around St. Francis Hospital swelled and a gift of land from Charles G. Roebling, along with $20,000 for an addition, helped to meet the urgent need for more space. The hospital continued to grow apace with the neighborhoods, often with the help of monetary gifts from the Roebling family.

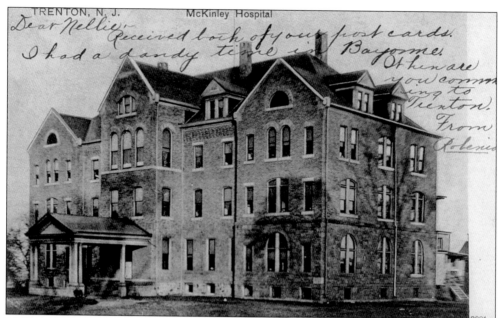

TRENTON, N. J. McKinley Hospital

Dear Nellie, Received both of your post cards. I had a dandy time in Bayonne. When are you comming to Trenton. From Roberie

MCKINLEY HOSPITAL. Now Helene Fuld-Capital Health Care System, Trenton's second hospital grew out of the Trenton City Dispensary, founded in 1887. Two years later, bigger quarters were needed and land on Brunswick Avenue was purchased. The hospital was renamed in 1902 to memorialize recently assassinated Pres. William McKinley. Many of Trenton's nurses were graduates of the hospital's School of Nursing. In 1959, the hospital was again renamed, this time for the late mother of Dr. Leonhard Fuld in recognition of his many charitable contributions. Recently joined with Mercer Hospital as Capital Health Care, Helene Fuld serves the North Ward and residents of nearby Lawrenceville.

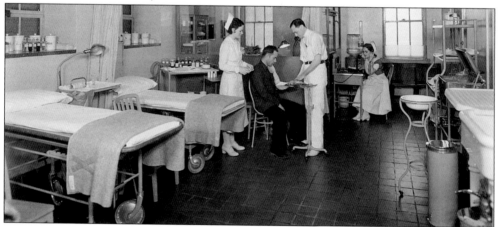

A MERCER HOSPITAL WARD ROOM. Mercer Hospital was dedicated in 1895 to care for Trenton's western residents. It was completely modern, and its operating room was touted as being as complete and perfect as any in the state. For much of its more than 100 years, the hospital has been in a constant state of remodeling and expansion. Added throughout this time were outpatient departments, administrative offices, nurses quarters, a nursing school, X-ray departments, new electric lighting for the operating rooms in 1901, a maternity building, and a tumor clinic in 1939. In 1936, there were some 4,000 patient visits to the Mercer Accident Ward, seen in this photograph.

THE TRENTON STATE PRISON. Built in the early 1830s by pioneer prison architect John Haviland, the Trenton prison became the model from which modern prisons are derived. Haviland based his plans on the Quaker concept that a prisoner should spend his sentence in solitude, repenting his deeds and seeking solace from the Lord. Shifting from the large, open rooms that housed prisoners until this time, the architect designed a half wheel, with five wings radiating from an inspection room behind the main doors. Individual cells and separated exercise yards helped reduce fights, plots, and attacks on wardens. Haviland's renderings for the Trenton Prison drew international attention, and people traveled from Europe to tour the grounds.

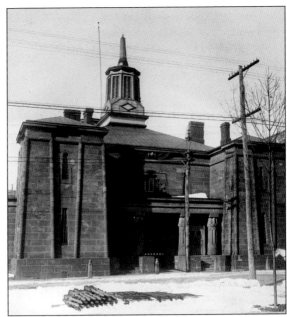

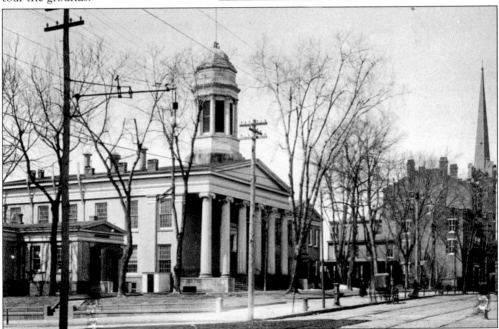

THE MERCER COUNTY COURTHOUSE, 1838–1901. Mercer County, named for the Revolutionary War general who died at the Battle of Princeton, was carved out of Somerset, Middlesex, and Hunterdon counties in 1838. The new, spacious courthouse was erected in the same year. It accommodated a basement jail, grand jury and witness rooms, quarters for the jailer's family on the first floor, and the courtroom and two jury rooms on the second floor. Later, the county outgrew the churchlike structure and moved to its current location at the corner of South Broad and Market Streets. The courthouse bell rang for court assemblies and momentous occasions such as the Capture of Richmond, the first message sent via the Roebling-made Atlantic cable, and the death of Pres. Abraham Lincoln.

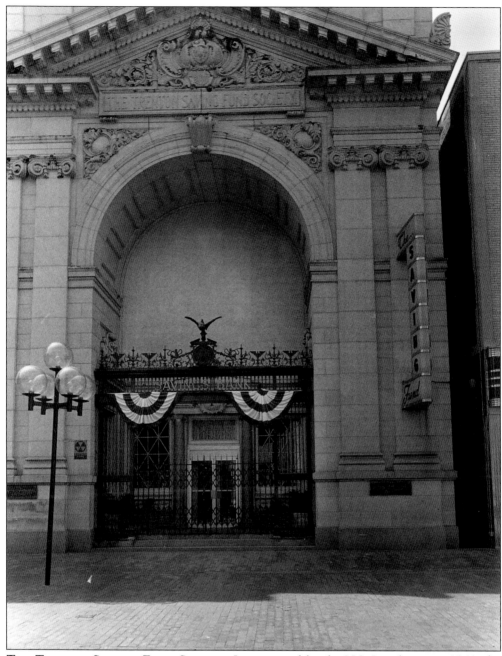

THE TRENTON SAVINGS FUND SOCIETY. Incorporated by the N.J. Legislature in 1844, the society was founded as an outgrowth of philanthropic sentiment by prominent members of the community to serve Trenton's work force. Designed in the Italian Renaissance style, the building cost $1,433 in April 1901. The elaborate gate across the entrance to the building was added later.

THE INTERIOR OF THE TRENTON SAVINGS FUND SOCIETY. Fine materials were lavished on the interior, which was furnished in marble, bronze, and mahogany. The latest modern banking equipment was installed for the clerks' use.

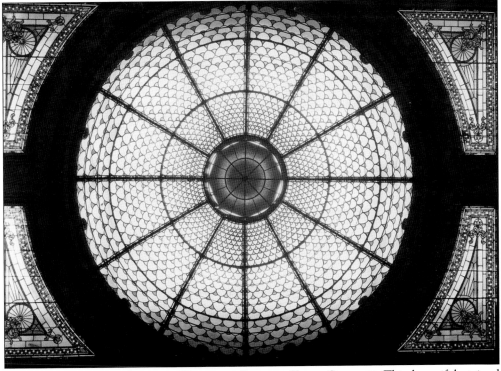

THE STAINED GLASS CEILING, TRENTON SAVINGS FUND SOCIETY. This beautiful stained glass ceiling was removed in 1962 and a more modern drop ceiling replaced it.

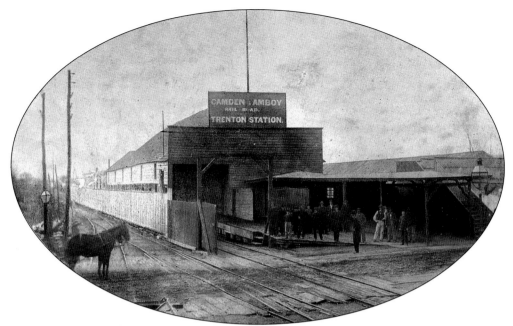

THE CAMDEN AND AMBOY RAILROAD STATION. In 1831, work began on a railway to move passengers and freight from south of Bordentown to South Amboy. Trenton's first rail depot was built on East State Street in 1837. As you can see, the station consisted of one rough wooden building where one could purchase a ticket to Philadelphia via Camden for $1.35 one way.

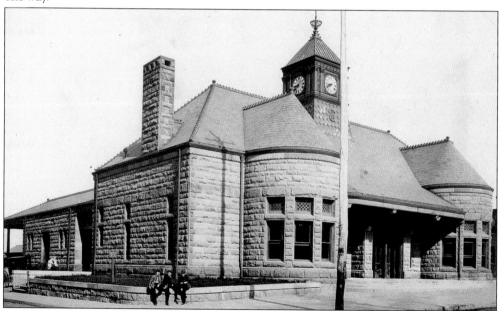

THE PENNSYLVANIA RAILROAD STATION. The passenger rail moved to South Clinton Street (later Avenue) in 1863. The station was unpopular from the beginning, as it was built at the same level as the rails, several feet below street level. Carriages dropped off passengers, who then had to carry luggage through a covered walk. It took less than 30 years for a new station to be built on the same site. The second station was razed in April 1972.

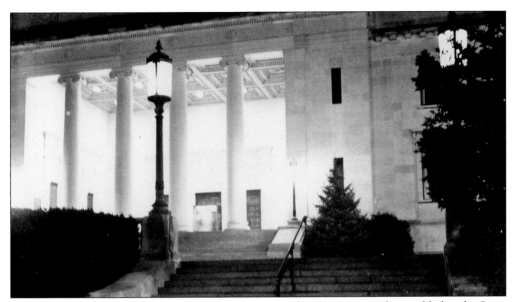

THE WAR MEMORIAL AT NIGHT. In November 1987, the War Memorial was added to the State Register of Historic Places. Designation to the National Register followed on December 11, 1987. The building is "an excellent example of the type of commemorative monument constructed throughout the United States in the years following the First World War" (*Trenton Times*, January 16, 1987). It was noted, too, as an example of art deco architecture.

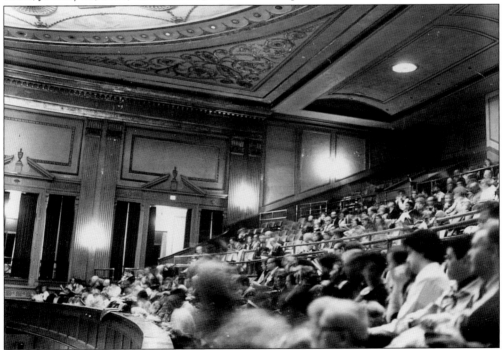

THE INTERIOR OF THE WAR MEMORIAL. Looking at this undated photograph, one can see some details of the interior of the War Memorial that have been restored. All molding, gilding, fixtures, and features were returned to their original state or were reproduced to repair the damages of time.

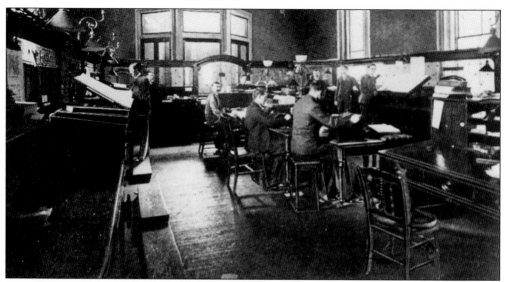

THE TRENTON BANKING COMPANY. Founded by subscription in 1804, Trenton's first bank stood on South Warren Street, at first in the old Hunterdon County Jail and Courthouse. The Trenton Banking Company was the site of one of Trenton's more daring robberies when, on Sunday, January 21, 1872, Mrs. John Hutchinson was passing by and heard quite a commotion coming from the interior. She promptly notified the police, who found two bound guards in an office. The robbers dashed out the back door after taking bonds and securities. A mysterious letter arrived a few weeks later, returning several thousand dollars.

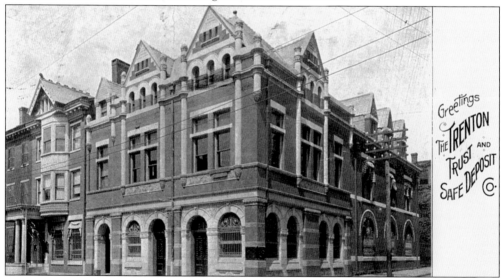

THE TRENTON TRUST AND SAFE DEPOSIT COMPANY. In 1888, the Real Estate, Safe Deposit, Trust, and Investment Company of New Jersey was founded in Trenton. The name was changed to the much briefer Trenton Trust and Safe Deposit Company a few years later. In 1925, the firm was housed in a new 14-story building, the tallest structure in town at the time. Since Col. Washington Roebling was active in the formation of the company, a bas-relief of the Brooklyn Bridge appears over the main entrance. Descendant Siegfried Roebling left his shares to his wife Mary Roebling, who became the first female president of a banking institution, as well as the first woman to hold a seat on the New York Stock Exchange.

THE STACY-TRENT HOTEL. At the end of WWI, a cry for an up-to-date Trenton hotel began. A $10,000 donation from the *Trenton Times* began a public drive that eventually collected about $1.8 million from 571 citizens and businesses. A corporation was created to own the building, which was to be located at State and Willow Streets. After some controversy, the name Stacy-Trent, honoring the first citizen and the town's namesake, was agreed to and the hotel opened in September 1921. For many years, the Stacy-Trent and the Hildebrecht competed for the honor of being the city's most popular hotel.

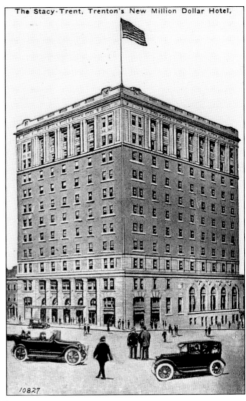

The Stacy-Trent, Trenton's New Million Dollar Hotel,

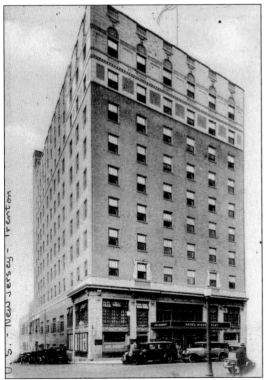

THE HOTEL HILDEBRECHT, WEST STATE STREET AND CHANCERY LANE. Charles G. Hildebrecht expanded his father's ice-cream and restaurant business by moving to new quarters at the corner of West State Street and Chancery Lane in 1924. Just four years later, he expanded again, this time moving upward with a ten-story hotel. Opened in July 1929, the new hotel never had a chance, with the onset of the Depression coming just a few months later. The hotel went into receivership and Hildebrecht was forced to sell the ice-cream business to Borden's. Hildebrecht died in 1934.

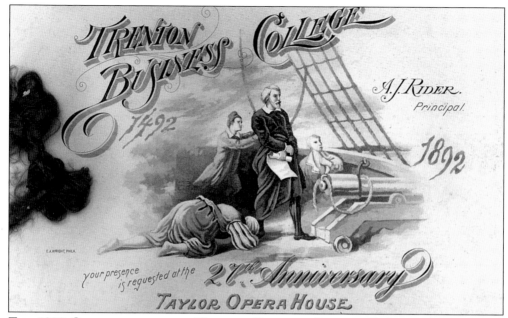

THE 1892 GRADUATION OF THE TRENTON BUSINESS COLLEGE. Today's Rider University began as a chain of business schools owned by the firm of Bryant and Stratton, whose goal was to have a business college in every city with a population of more than 10,000. The Trenton school opened its doors in 1865 and was in operation when Andrew J. Rider became principal. In 1897, after several moves and the addition of several classes, the school was incorporated as the Rider Business College. Tuition in 1901 was $275 and included lessons in English, business, stenography (shorthand and typing), and the telegraph.

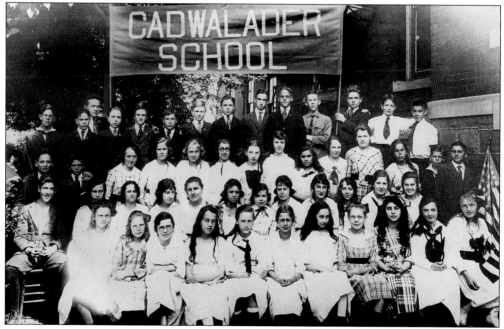

THE CADWALADER SCHOOL GRADUATING CLASS OF 1919. A typed class list accompanies this photograph from 1919.

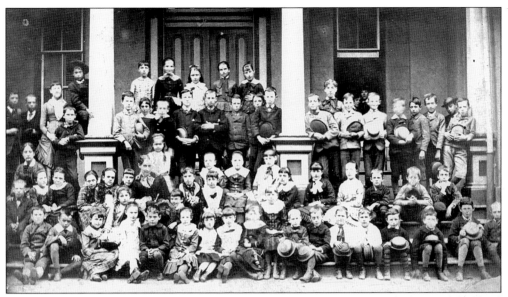

THE TRENTON MODEL SCHOOL, 1900. Along with the Normal School, the Model School educated both Trenton's children and New Jersey's youthful teaching force. This photograph probably shows all of the students enrolled in 1900; the younger children are seated on the steps; the older ones stand on the porch.

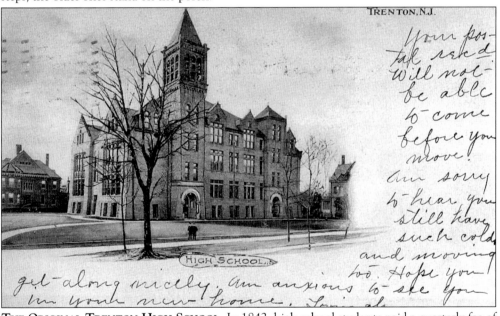

THE ORIGINAL TRENTON HIGH SCHOOL. In 1842, high school students paid a quarterly fee of $1.50 to attend classes in reading, writing, arithmetic, and geography. Studies that were more complex cost $2 more; and for $7 students learned Latin, French, and Greek. By 1848, classes were free. In 1874, a separate high school was built and by 1900, that space was sorely outgrown. This school on Hamilton and Chestnut Avenues took ten years to plan and by 1905, it was crowded. An athletic field, for which the students themselves raised funds, and a pipe organ were features of the old high school. On January 4, 1932, students moved into the current high school located on Chambers Street.

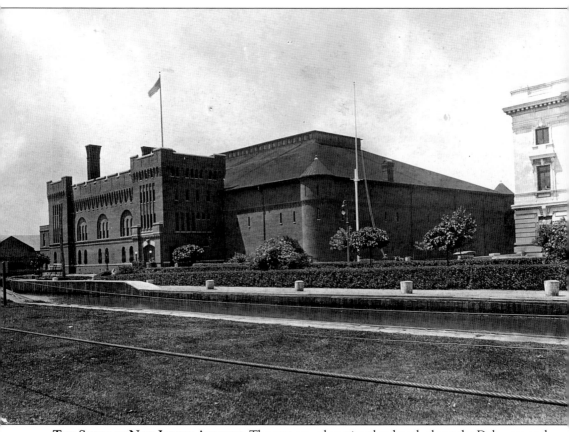

THE STATE OF NEW JERSEY ARMORY. The armory, a longtime landmark along the Delaware and Raritan Canal, was built by the State in 1905. It is fondly remembered as the site of many civic and entertainment events. When the State Department of Defense moved to Eggerts Crossing Road in Lawrenceville, the City moved in, using much of the building for office and storage space. The armory was destroyed in a spectacular fire on July 16, 1975, in which temperatures were estimated to have reached 250 degrees. Besides decimating 69 offices, the fire consumed tax, building, and zoning records, as well as blueprints and contracts. Today the site is used for parking at city hall.

Five

DOWNTOWN

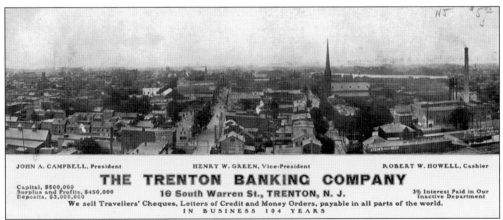

JOHN A. CAMPBELL, President HENRY W. GREEN, Vice-President ROBERT W. HOWELL, Cashier

THE TRENTON BANKING COMPANY

Capital, $500,000
Surplus and Profits, $450,000 16 South Warren St., TRENTON, N. J. 3% Interest Paid in Our
Deposits, $3,000,000 Inactive Department

We sell Travellers' Cheques, Letters of Credit and Money Orders, payable in all parts of the world.
IN BUSINESS 104 YEARS

A VIEW OF DOWNTOWN TRENTON. Since William Trent laid out his town almost 300 years ago, the hub of town has always been Second (now State) Street between King (Warren) and Queen (Broad) Streets. Downtown radiates outward from here, reaching toward Montgomery or Stockton Streets to the east, Front Street to the south, Calhoun Street to the west, and Perry Street to the north. From the earliest taverns and Abram Hunt's shop to the c. 1900 eight-story skyscraper of the Broad Street Bank and today's recently restored public buildings, downtown Trenton has always been bustling with the energy of its citizens.

STATE AND BROAD STREETS, 1915. Residents who lived in the Mercer-Hunterdon region came to the city for everything from farm equipment to the finest clothing to a restaurant for a special occasion.

THE BRUSH FACTORY. From 1880 to 1935, Louis N. Clayton manufactured several different types of brushes. The location of his business often changed, moving from North Greene Street (now Broad) to addresses up and down Warren Street. From 1916 to 1935, Clayton stayed put at 23 South Warren Street.

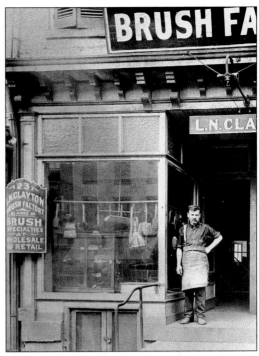

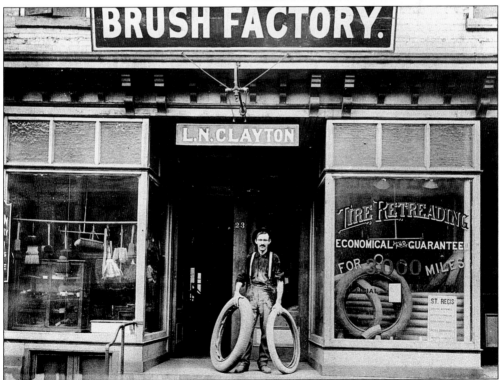

TIRE REPAIRS. Within the year, Louis Clayton branched out to include tire repairs and retreading. Having settled at 23 South Warren, he converted half the building to accommodate his new business.

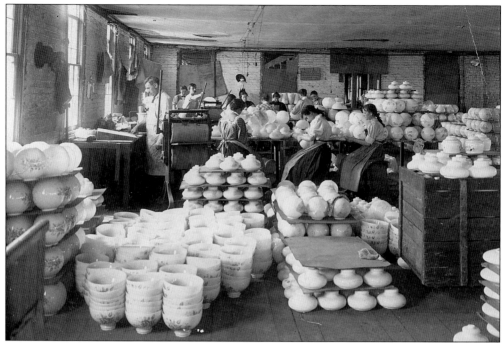

THE CLARK BROTHERS COMPANY. Brothers Peter, Charles, and Joseph Clark began their company at 147 North Warren Street. Four additional brothers and a sister later joined them. Clark Brothers began as a china and glass wholesaler in 1882 and expanded into pottery manufacturing in 1887. The company employed women to decorate the lamp globes imported from Staffordshire, England. On the back of this picture, an unaccredited note states, "Papa worked in this shop but does not appear in this picture." That statement is just one of the many mysteries of the Trenton Public Library's Trentoniana Collection.

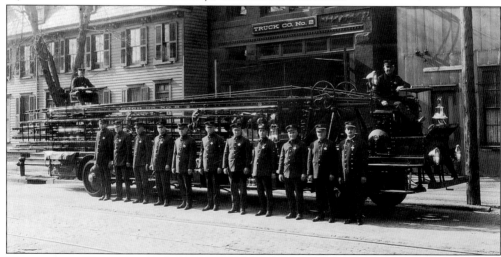

VOLUNTEERS. Trenton's volunteer fire companies were replaced by a paid fire department by Common Council ordinance in 1892. The old horse-drawn engines were done away with when a modern fleet of 27 motor vehicles was put into service in 1918. The Perry Street headquarters was built in 1927, and work began in 1998 on a major restoration project and construction of a separate, larger garage building.

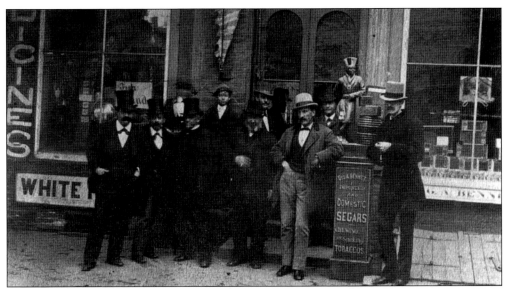

THE SHOP OF GEORGE BENNETT, NORTH WARREN STREET, c. 1873. Bennett's tobacco shop was one of the local places where men gathered to swap news and gossip. The cigar Indian, shown at the right, was unique in that it was made of metal while most were made of wood; its wooden base was inscribed "George Bennett. Imported and domestic segars. Chewing and smoking tobaccos." A note on the back of this photograph identifies the men as George Bennett, proprietor; Bennett's father, 'Pop' Bennett; 'Bucky' Napton, mayor of Trenton for eight one-year terms; an unidentified member of the Yard family; Harry Lewis; 'Squire' George Bretton; Bill Green; Sen. John Taylor; Louis Burke; and William H. Grant.

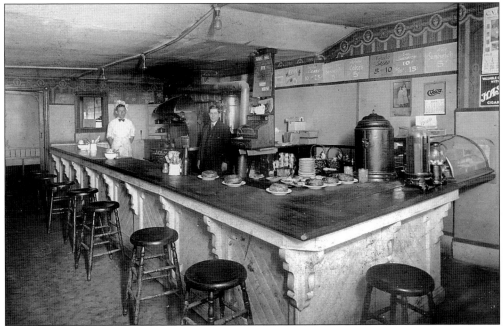

TED FORKER'S LUNCH WAGON. The precursor to the American diner, the Lunch Wagon was made to the specifications of the owner and then towed to the owner's plot of land. Fully outfitted, the new restaurant could be opened for business within just a few days.

THE F.W. DONNELLY COMPANY. Civil War Gen. Richard Augustus Donnelly opened a men's shop in 1867. His son Frederick W. Donnelly joined him in 1895. In time the two split the business, and F.W. Donnelly moved to South Broad Street. There, he built the store's reputation by offering the finest brand names in men's and boys' clothing, as well as a private line of clothes. In 1911, F.W. Donnelly became the mayor of Trenton, handing over the management of the store to his son Frederick S. Donnelly. F.S. Donnelly died in 1932, forcing the mayor to resume responsibility for the company. In 1971, the fourth generation of Donnellys moved the shop to nearby Lawrenceville.

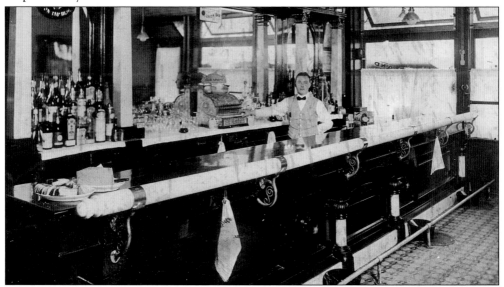

ALBERTI'S. Gus Alberti was the owner of this saloon from 1910 to 1915. After it closed, Alberti's entered the delicatessen business and eventually grew into one of Trenton's popular restaurants. One can still find period restaurants with tin ceilings and long gleaming bars as part of the decor.

THE S.P. DUNHAM & COMPANY.
Sering P. Dunham came to
Trenton in September 1882 and
became interested in the dry
goods business owned by the late
H.G. Scudder. Dunham and
John H. Scudder formed a
partnership that continued until
Scudder retired in 1895. The
firm's name was changed to S.P.
Dunham & Company.

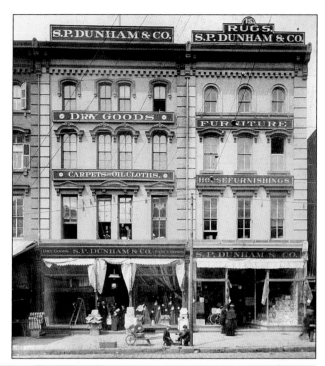

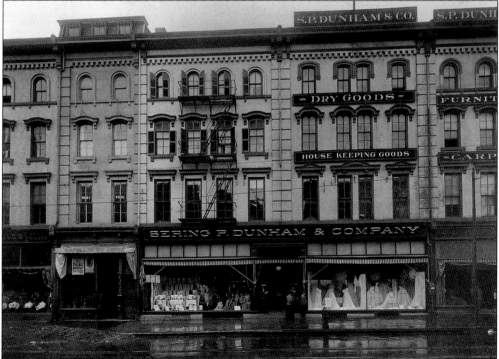

THE DUNHAM BLOCK. Building by building, S.P. Dunham expanded his dry goods shop. In the first photograph, the shop occupies two buildings. Within a few years, Dunham had expanded into the next storefront, installed a new entrance, and changed his sign. The last Dunham's branch, in Morrisville, Pennsylvania, closed in the mid-1990s.

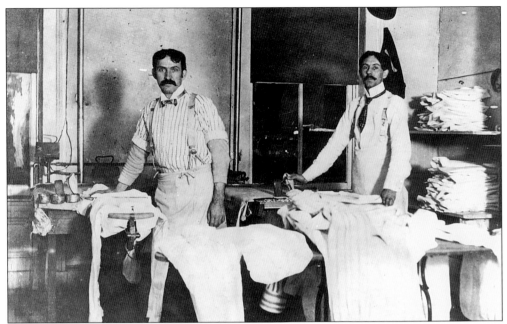

THE BLAKELY STEAM LAUNDRY. An 1898 advertisement touted Blakely's method of using filtered water with the best soaps and starches in the best and most-approved machinery, along with the Blakely Edge for collars and cuffs.

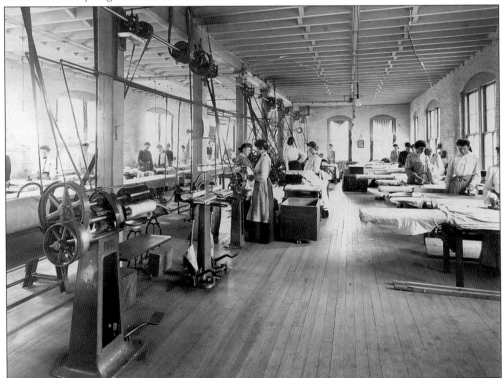

BLAKELY'S INTERIOR. In this photograph of the interior of Blakely's laundry, women labor at the machines.

NORTH BROAD STREET FROM THE OPPOSITE CORNER OF BROAD AND STATE STREETS. The first building on the right is the old city hall; the second is Yard's Department Store.

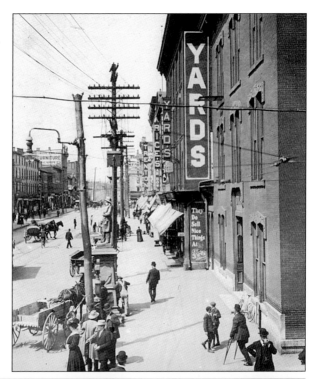

STATE AND BROAD STREETS AT NIGHT. In 1898, the look of downtown was very different at night from the way it appears today. The well-lit building in the upper center is identified as the John L. Murphy Publishing Company. The 1881 City Directory, found on the website of the Old Mill Society, indicates that Murphy was the proprietor of the *State Gazette*, located at that time at the corner of State and Greene Streets. Based on that information, this photograph was taken from the east side of North Broad Street, above the old city hall, looking down toward State Street.

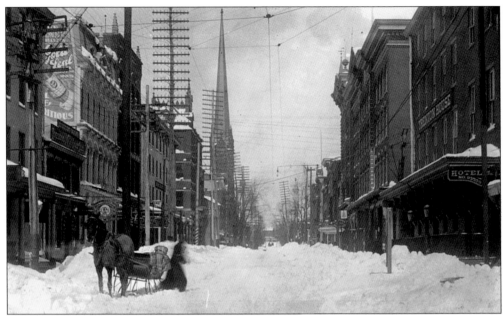

Warren Street, Looking North toward St. Mary's. A storm on February 6 and 7, 1899, left 12 inches of snow on the ground. The blizzard that followed on February 12 and 13 left an additional 22 inches behind. Trenton was totally shut down. The *True American* newspaper reported on February 14 that the city street commissioner was seeking 100 men to clear the corners and main squares. The Pennsylvania Railroad Company also was looking for 100 able-bodied men willing to clear the tracks.

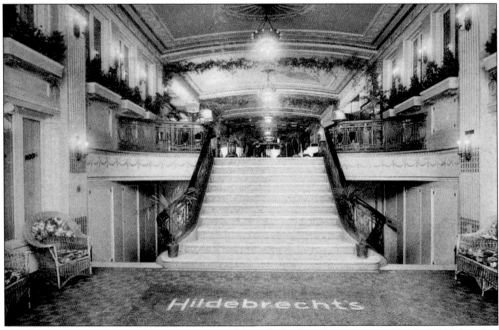

The Lobby of the Hotel Hildebrecht. Although this hotel was operated by the Hildebrechts for only a short time, the family spared no expense in making it a tasteful, inviting hostelry. From start to finish, $1.5 million was spent in the late 1920s.

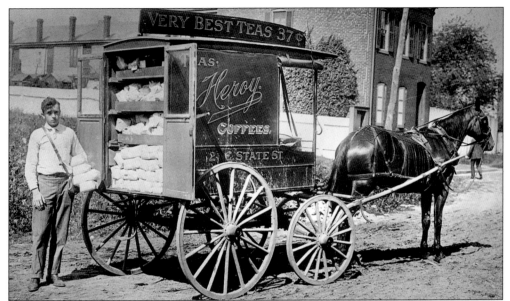

HEROY'S TEA AND COFFEE WAGON. Robert R. Heroy first appears in the 1899 City Directory with "teas & c." as his business. Moving around the city as the company expanded and contracted, Heroy's was listed in directories for the next 78 years with tea as its staple product and with other products, such as coffee, butter, and spices, also listed from year to year. Looking at the photograph at the beginning of this chapter, one can see an advertisement for Heroy's at the very top of the signs.

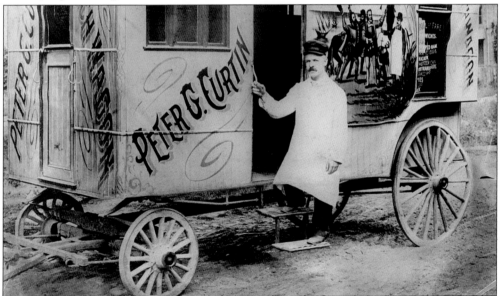

PETER CURTIN'S LUNCH WAGON. Apparently, Peter Curtin was there with fresh coffee when Christopher Columbus landed; the scene is clearly reproduced on the side of his lunch wagon. The wagon, built by the Trenton firm of Fitzgibbon and Crisp, took up its nightly stand in front of the old city hall in 1894. From 9 p.m. to 4:30 a.m., missing only one night in 17 years, Curtin provided sandwiches, side dishes, pies, rice pudding, coffee, and milk. Like today's diners, Curtin's got a lot of business after the saloons closed and before the last trolley run.

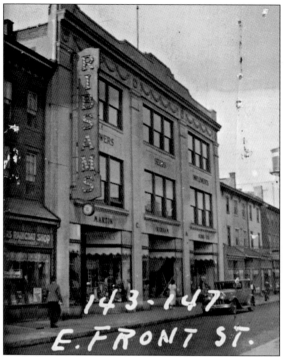

143-147 E. FRONT ST.

RIBSAM'S. Located at Broad and Front Streets when it opened for business in 1893, Ribsam's became the premier provider of seeds, tools, and farm equipment. Outgrowing the one floor it occupied, the store relocated to a spacious three-story building. Three separate doors on the first floor led to the seed, flower, and implements departments. The flower department featured a two-story conservatory full of rare flowers. On the second and third floors, farmers could purchase heavy equipment. On opening day, March 23, 1927, some 15,000 people passed through the front doors. Although he was in spacious new quarters, Ribsam retained an older building on Jackson Street for storage. The Ribsam family continues to meet Trentonians' floral needs in a shop on the western side of town.

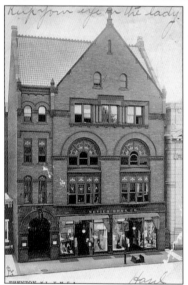

THE YMCA ON EAST STATE STREET. Trenton began its association with the Young Men's Christian Association in 1856. The YMCA was located in various rented rooms throughout the city and offered a healthy assortment of lectures, debates, and other educational programs. In the 1880s, the gymnasium was located in the second Masonic Hall. The building on East State Street was erected in 1892 and featured an auditorium for 1,000, a gym, a swimming pool, dormitories, bowling alleys, reading rooms, and classrooms. Larger quarters were required and a new building at East State and Clinton Streets was erected in 1919 on the site of the former Dolton home. Entering the 21st century, the YMCA embarked on constructing a new facility located on Hamilton Avenue in one of the old Roebling Company factories.

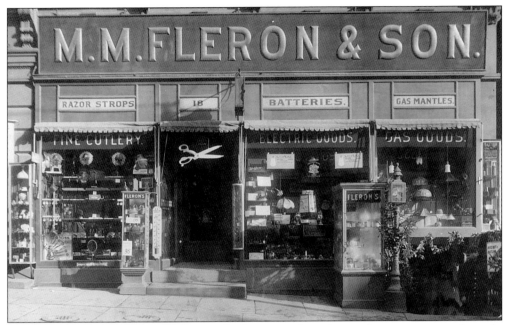

M.M. Fleron & Son. M.M. Fleron & Son carried an interesting assortment of goods, from razor strops to gas supplies to radio and telegraph parts manufactured by the company. The stock must have overfilled the store, as two display cases were set up on the sidewalk. When son Russell Fleron passed away in 1958, the company was called Fleron Beauty and Supply Company.

The F.W. Woolworth Company, 1951. If you had $39.95 in 1951, you could buy Woolworth's top-of-the-line bicycle, or perhaps a lamp. If your pockets were a little low, how about a Swiss steak dinner for 60 cents? Woolworth came to Trenton in 1907 and on February 1, 1951, opened the new and improved Woolworth building on East State Street. Judging by a glowing report in the March 1951 *Trenton* magazine, Trentonians were thrilled with the expanded store, which featuring two sales floor joined by an illuminated, glass-walled escalator. Although the store had a land lease through 1994, Woolworth expired before the lease did.

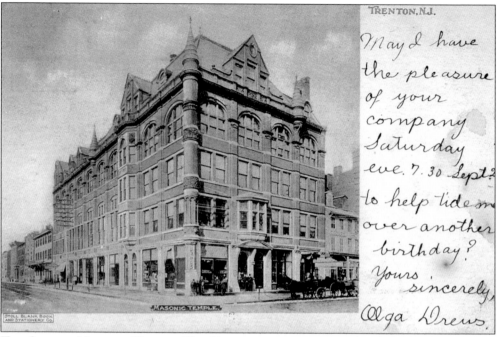

THE SECOND MASONIC TEMPLE. This Victorian extravaganza replaced the house of Abram Hunt, the gentleman who played host to Hessian Cmdr. Johann Rall on Christmas night of 1776. The National Basketball Association recognizes the second temple as the site of the first professional basketball game held in the United States. When the Trenton YMCA met the Brooklyn YMCA in 1869, each home team player got a piece of the gate: $15 each. A remaining dollar went to the team captain, Fred Cooper. At that time teams played with seven men; so, the total take for the evening was $106.

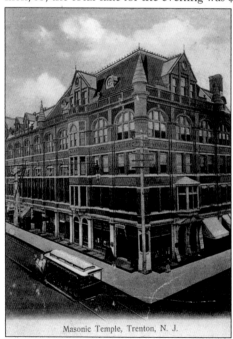

Masonic Temple, Trenton, N. J.

WARREN STREET. The Masonic Temple proudly dominates the corner of Warren Street in this photograph, which was taken looking toward the north.

THE ELKS LODGE, NORTH WARREN STREET.
The Benevolent and Protective Order of
Elks, Trenton Lodge No. 105, opened for
members on January 1, 1912. The lodge,
which cost $100,000, offered bowling, pool,
and billiards in the basement and a reception
hall and grillroom on the first floor. The
second floor had a library, a parlor, and an
entertainment hall complete with stage.
The lodge room occupied the third floor and
was two stories high. On the fourth floor were
five bedrooms. The building was topped by a
roof garden.

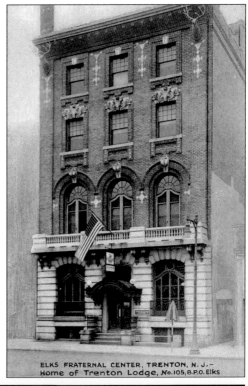

ELKS FRATERNAL CENTER, TRENTON, N. J.—
Home of Trenton Lodge, No.105, B.P.O. Elks

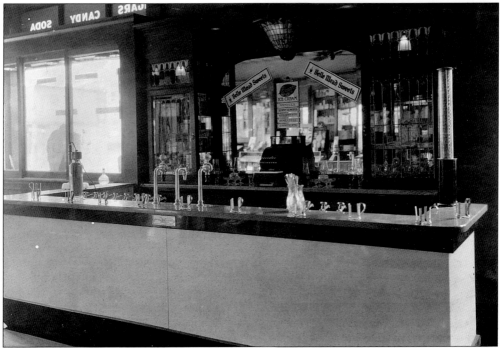

A SODA FOUNTAIN. Fountains like this were in many Trenton drugstores. Ice-cream floats,
sundaes, and other treats, such as Belle Mead Sweets chocolates could be enjoyed while waiting
for a prescription.

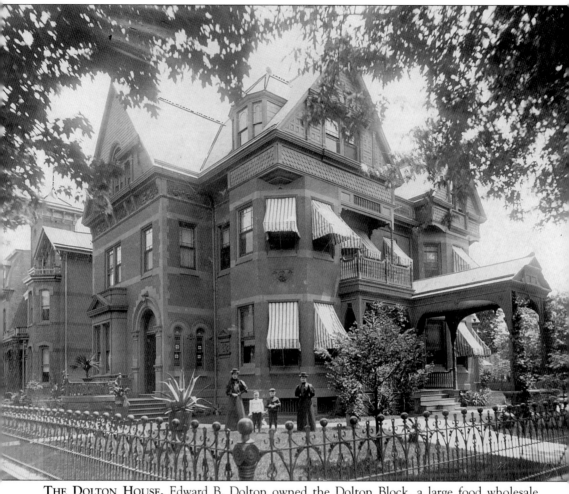

THE DOLTON HOUSE. Edward B. Dolton owned the Dolton Block, a large food wholesale establishment on North Warren Street. Shown, from left to right, are Mrs. Edward B. Dolton, Edward B. Dolton Jr., William R. Dolton, and Emma Dolton. By the 1950s, the YMCA was located at this site.

Six

CITY LIFE

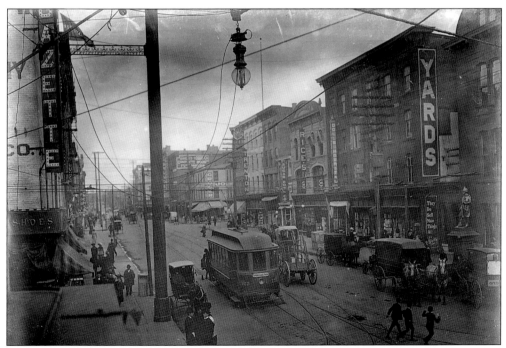

LIFE IN TRENTON. Large or small, everything that has happened and is happening is the stuff of city life. To conclude this tribute to the city, which began with Mahlon Stacy and his small group of Quaker travelers, this chapter contains just a fraction of Trenton's people, neighborhoods, organizations, businesses, and events.

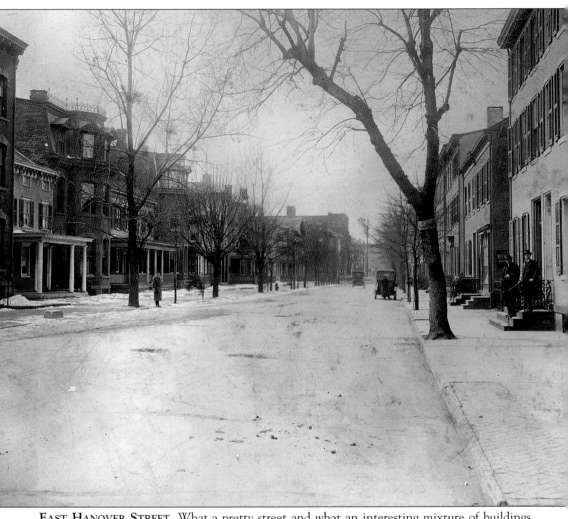

EAST HANOVER STREET. What a pretty street and what an interesting mixture of buildings. Many of the streets looked like this one, as the bustling center of downtown gave way to quiet neighborhoods.

THE CADWALADER MANSION. Shown here are Edmund C. Hill, Dorothy Hill, and Elbridge G. Weir. Not immediately determined is whether a figure identified as Major is the dog or one of the two gentlemen at the rear. Hill, a caterer and real estate agent, convinced the citizens of Trenton that what they really wanted was a large spacious park where they could commune with nature and their neighbors. Land for Cadwalader Park was purchased from the Cadwalader family. The landscape firm of Frederick Law Olmsted was hired to create the park and several surrounding neighborhoods. The park and the adjacent Berkeley Square Historic District are both listed on the National Register of Historic Places. Hill seemed to have a finger in most of the pies in Trenton and kept meticulous scrapbooks detailing everything from the most mundane to the greatest moments of his life. Fortunately, he donated all of these books to the Trenton Free Public Library.

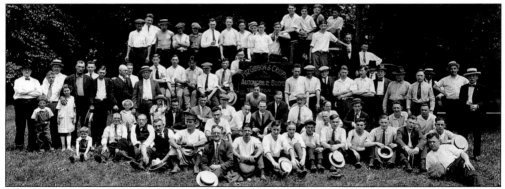

THE 1923 COMPANY PICNIC, FITZGIBBON AND CRISP. Patrick J. Fitzgibbon first appears in the City Directory of 1875. In 1879, Philip D. Crisp joined him in Fitzgibbon and Crisp. The company also used the moniker Union Carriage Works. The company's products ranged from the lightest of track sulkies to the family coach to the heaviest of trucks and included phaetons and buggies. The company specialized in physician's phaetons and shipped to all of the United States and South America. Incorporated in 1893, the company had an annual production of 150 vehicles. When progress brought the automobile to this country, Fitzgibbon and Crisp shifted to automobile body production, including the Trenton-made Mercer automobile, a sports-racing car with backing from, among others, the Roebling and Kuser families. Peak production of the Mercer came in 1916 when some 1,400 cars were built. This picture of the 1923 Fitzgibbon and Crisp Company is interesting in that there appears to be one lone woman at the gathering.

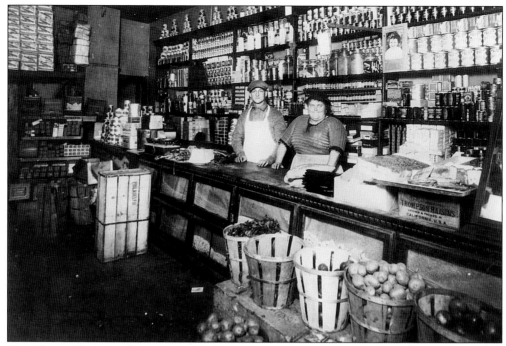

THE NARDI GROCERY STORE, IN THE CHAMBERSBURG SECTION. This popular store started as a grocery and evolved into a bakery. It was staffed entirely by family members until it closed in 1970. Thomas Sr. and Frances Nardi are shown in this photograph; Mrs. Nardi and other family members still live in Trenton.

THE ALEDA APARTMENTS. At the corner of North Montgomery and Hanover Streets, the Aleda was Trenton's first upscale apartment building. Each suite of rooms featured all the amenities, including maid's quarters and buzzers set in the dining room floor, which allowed the hostess to signal the maid for the next course. Walter Scott Lenox, founder of Lenox China, made the Aleda his home for a number of years.

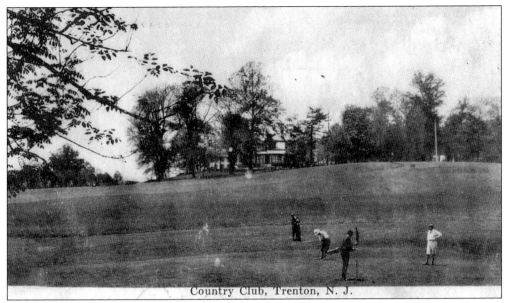

Country Club, Trenton, N. J.

THE TRENTON COUNTRY CLUB, SULLIVAN WAY. This early picture shows the Trenton Country Club on Sullivan Way. The street was named for Gen. John Sullivan, who led one half of the American army to its appointment with destiny on December 25 and 26, 1776.

HMS PINAFORE, PRESENTED BY THE AEOLIAN CHOIR. Several Trenton quartets formed this popular choral group in October 1928. The choir set high standards for itself and for new members. Founded in 1928, the choir hired a professional vocal director in 1934 and presented a wide range of vocal performances to "aid the cultural life of Trenton." (*Trenton* magazine, April 1938.)

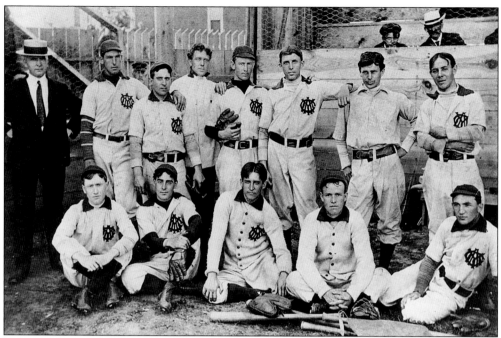

THE 1902 YMCA BASEBALL TEAM. This semiprofessional team was formed by the Trenton YMCA in 1895. The team disbanded ten years later, although it had been playing three games a week against local and out-of-town teams. The team even played an occasional game against teams of the National and American Leagues. Trenton has had a long love affair with the national game. Local lore has it that when Willie Mays, fresh from the Negro Southern League, joined the New York Giants farm team in 1947, his hosts bought his first professional glove. Water Front Park, located alongside the Delaware River, hosts the Boston Red Socks Double A team, the Trenton Thunder.

THE PARK AVENUE ISLAND CANOE CLUB. Canoeing the Delaware River was a favorite activity in the late-19th and early-20th centuries when this club was in existence. Founded in 1889, the Park Avenue Island Canoe Association bought White's Island in that same year. Similar clubs occupied other small islands in the river, and some clubs were located along the shoreline. All were located above the Calhoun Street Bridge. The Trenton Canoe Club was founded in 1884, and its clubhouse at the foot of Gouverneur Avenue was still standing in 1960. Clubs often took the names of Native American tribes. The last club, the Mohawk, lost its Hermitage Avenue clubhouse to fire in 1970. The pictures that follow are of the Park Island Club. (The Trenton Free Public Library.)

TENNIS. With no clay courts and no fence, only a field and a net complete this tennis "court."

CROQUET. Fine hats and skirts made up the outfits of these women on the croquet field.

POSING FOR THE CAMERA. Here, some sports enthusiasts take a short break from recreation.

BICYCLING. These hardy few bundled up to enjoy a bike ride in the snow.

114

RAFTING. These folks took advantage of a beautiful day and went for a cruise on the water.

IN THE SHADE. On what could have been a hot day, this group enjoys the shade of a large tent.

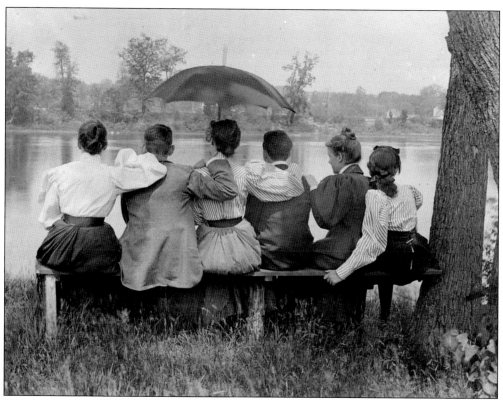

CONTEMPLATION. Here, we can join this group of friends as they gaze out upon the scenery.

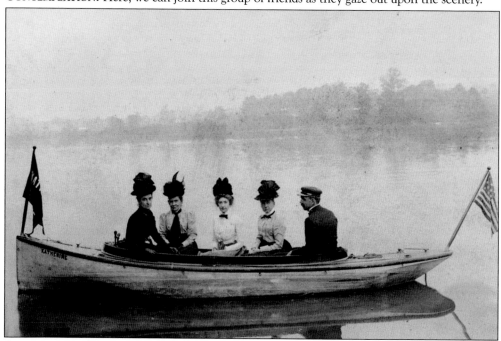

CROSSING THE RIVER. Surely this boat did not move very quickly over the water. If it had, the ladies' hats would have been blown away.

DISEMBARKING ALONG THE RIVER. One can just glimpse a team of horses pulling a wagon from an unseen ferry up the path to Trenton.

THE STEAMBOAT _TWILIGHT_. A frequent sight from Trenton to Philadelphia, the steamboat was a way of river life from the 1870s to the 1910s. John Fitch (1743–1798), who manufactured guns for American patriots during the Revolutionary War in his Trenton workshop, turned his attention to the steam engine and had four steamboats plying the Delaware River from 1786 to 1790. Robert Fulton, who receives credit for operating the first successful steamboat, did not have his _Clermont_ operational until 1807.

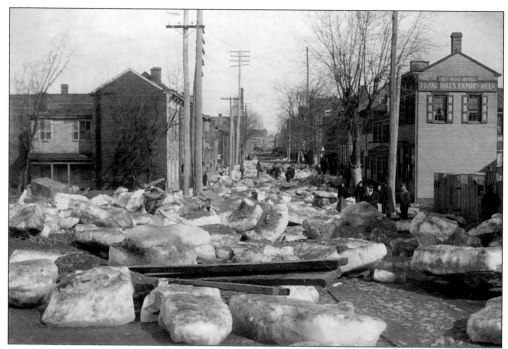

ICE ON FAIR STREET, MARCH 1904. Winters were often hard in Trenton. The Delaware River left behind huge chunks and slabs of ice, which were slowed by Trenton's rocky falls. The Blizzard of 1888 lasted four days and left huge snowdrifts as high as second-floor bedroom windows.

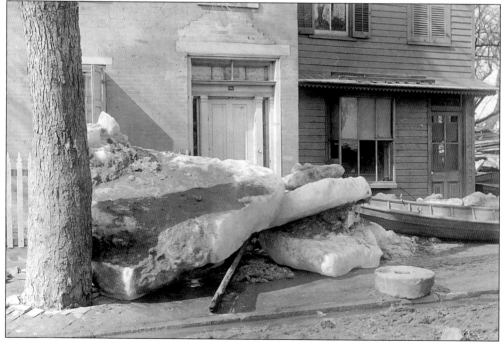

ICE CHUNKS ON FERRY STREET. This view is also from the March 1904 disaster when the Delaware River, in the midst of the spring rush, left slabs of ice in its wake.

THE REMAINS OF AN ICEHOUSE. This picture is actually of Morrisville, Pennsylvania, with which Trenton shares the head of the Delaware's navigable waters. One can see the Calhoun Street Bridge, or Upper Bridge, in the distance.

THE ASSUNPINK CREEK AT MONTGOMERY STREET. Several roads cross over the Assunpink Creek as it meanders through Trenton. This photograph shows the Montgomery Street Bridge. Water has frozen at the base of the bridge.

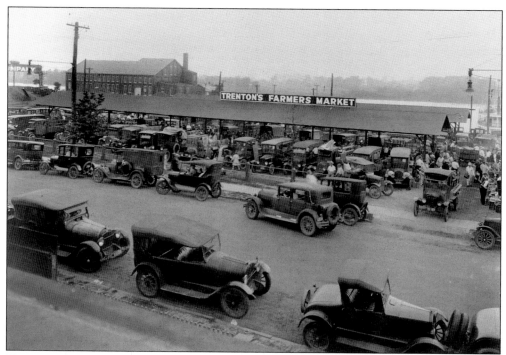

TRENTON'S FARMERS MARKET. This picture shows the market, located along the Delaware River, next to the Cooper Iron Works. The market is now located just outside the city borders in Lawrence.

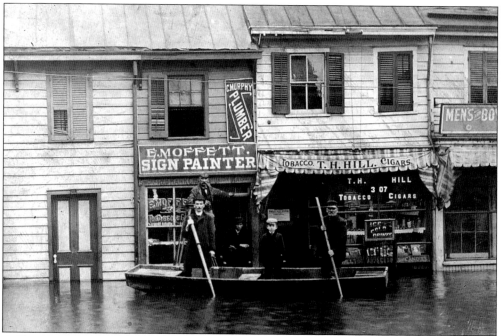

A FLOOD, SOUTH WARREN STREET. The Delaware River often flooded this commercial district, where South Warren Street slopes down toward the water. While the street still slopes downward, the district is now immune from all but the severest rains.

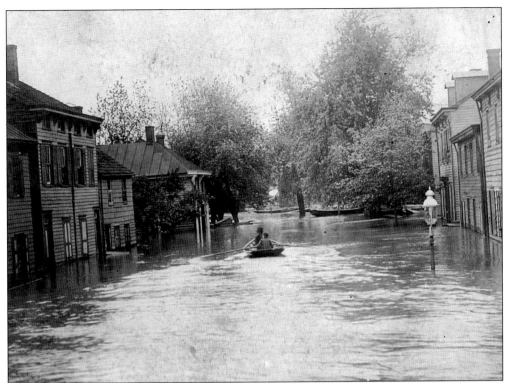

FAIR STREET, OCTOBER 11, 1903. Nine bridges were swept away by this storm. Homes and businesses below Front Street were often flooded. The 1999 floods caused by Hurricane Floyd left Mulberry Street resembling this 1903 photograph.

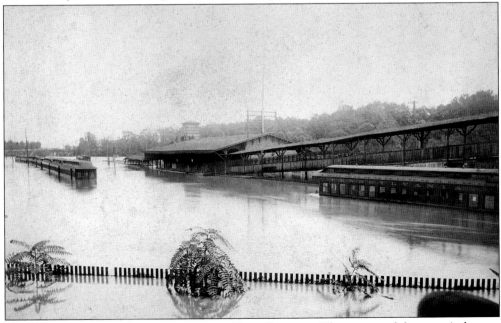

THE ASSUNPINK CREEK, ALONGSIDE THE RAIL STATION. The extent of the storm's damage can be seen in this photograph, taken on September 27, 1882.

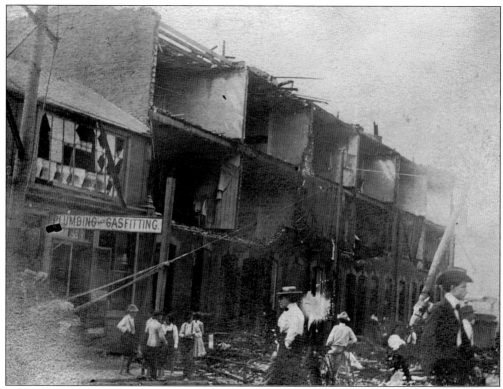

THE AFTERMATH OF A CYCLONE. More than $200,000 in damage resulted from this August 10, 1902 storm. The city's Electric House was flooded, leaving Trenton without electricity. The cyclone destroyed the Scudder Lumberyard on Perry Street and inflicted many thousands of dollars damage on the Crescent Pottery.

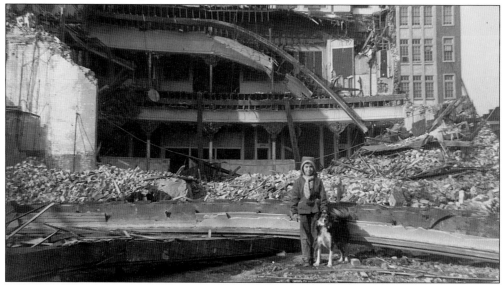

DANIELLE HAVENS AT THE STATE STREET THEATER. The daughter of Fire Chief Meredith Havens and her companion stand in front of the State Street Theater, a popular movie palace until its demolition in January 1951.

THE DRIVE CHUTE AND RAFT, YMCA CAMP WILSON. There is nothing better on a hot summer afternoon when there is a river nearby. Many Trentonians still recall the days when scenes like this were common. Camp Wilson was located some 25 miles above Trenton, just offshore from Frenchtown. Room and board for Trenton's youth was $11 per week with a $2 registration fee.

A LAZY DAY. Ed Anderson spends a bucolic day along the Delaware River. This charming photograph was found in a file at the Trentoniana Collection of the Trenton Free Public Library.

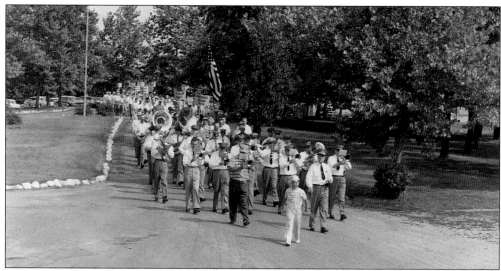

THE ROEBLING COMPANY PICNIC PARADE. The Roebling Company management instilled pride in its employees by sponsoring many planned social activities. Picnics were just one of the many ways that allowed employees from throughout the factories and the shipping, warehouse, and administrative departments to get together. The company band is in full swing upon entering the park grounds.

THE ROEBLING BASEBALL TEAM. Unfortunately, this team photograph does not identify the players. It is easy to see that the men are enjoying themselves.

124

THE ROEBLING SOFTBALL TEAM. The women, too, are unidentified in this company photograph. Photographs such as the four seen here often appeared in *Roebling*, the company's in-house magazine.

THE ROEBLING BASKETBALL TEAM. The Trenton Tigers were the 1947–1948 champions of the City Industrial League. Proud members of the championship team are, from left to right, Coach Ted Kearns, Ellsworth "Cherry" Williams, Pete Rossi, Charles Budd, Mario Rossi, Eddie Kissco, Gil Rossi, George Abel, George Borick, Harold "Tiny" Updike, Charles Kovacs, and an unidentified union representative serving as assistant coach.

PETER CARNEY AND HIS TROPHIES.
Edward Lewis Kerns was having a tough time coming up with a name and icon for his fledgling bottling business when it occurred to him that his own initials could provide both. The E.L. Kerns company had a strong, majestic forest creature to symbolize its place in the world of bottled beverages. Kerns was an avid sportsman, who sponsored the E.L. Kerns Basketball Club. Peter Carney was undoubtedly a member of that club.

THE 1932 E.L. KERNS CHAMPION BOWLERS. The trophies kept rolling in for E.L. Kerns's teams. This team captured the 1932 bowling championship.

CAROL DONNINI. Carol Donnini was the daughter of Emilio and Jennie C. Donnini of Ceasare's Meat Market, an old Chambersburg landmark. She certainly seems confident, or perhaps wary, atop this sturdy pony.

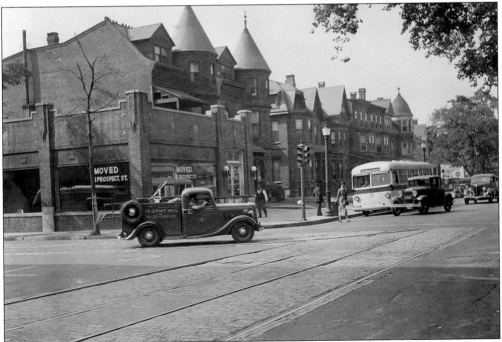

CLINTON AND EAST STATE STREETS. Often, one can date photographs by looking at the cars, the trucks, the window signs, or the clothing worn by the people pictured.

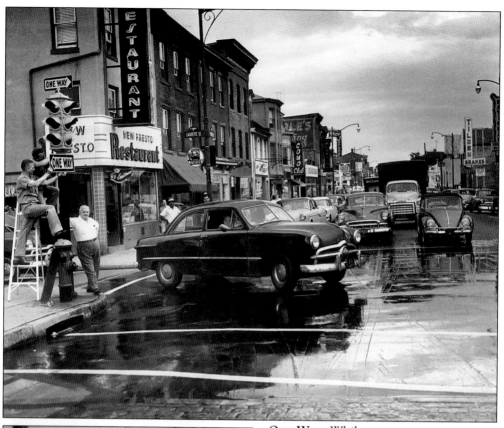

ONE WAY. While one man repairs a traffic light, his partner gives motorists at the corner of Lafayette and Broad Streets a helpful hint.

CAPITOL TOMATO PIE. The tomato pie is a classic part of life in Trenton. The minimalist vision of pizza, a tomato pie has a very thin crust, fresh chopped tomatoes, and little cheese. Although the Capitol is no more, several Trenton restaurants carry on the art of the tomato pie.